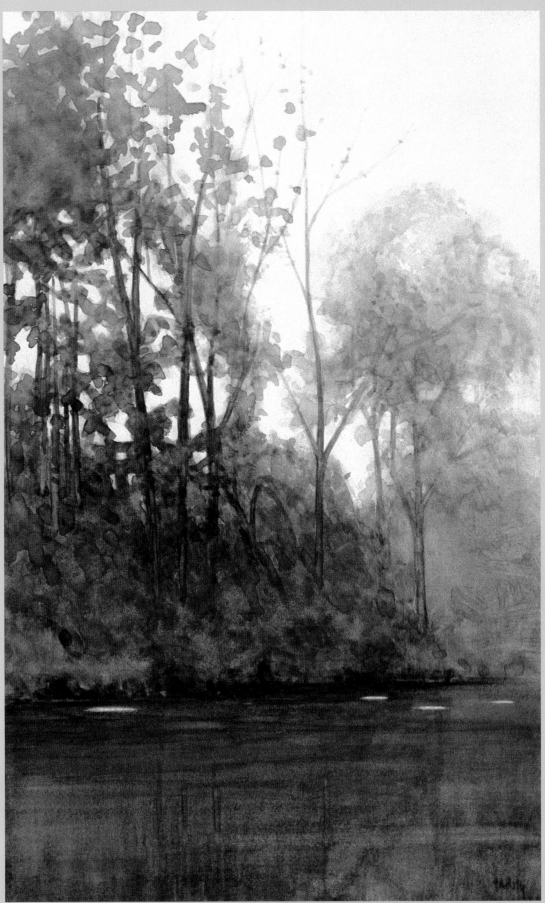

RISING TROUT, 13⅜″ × 8⅜″ (34.0 × 21.3 cm), *courtesy Stremmel Galleries Ltd., Reno, Nevada.*

PAINTING NATURE'S QUIET PLACES

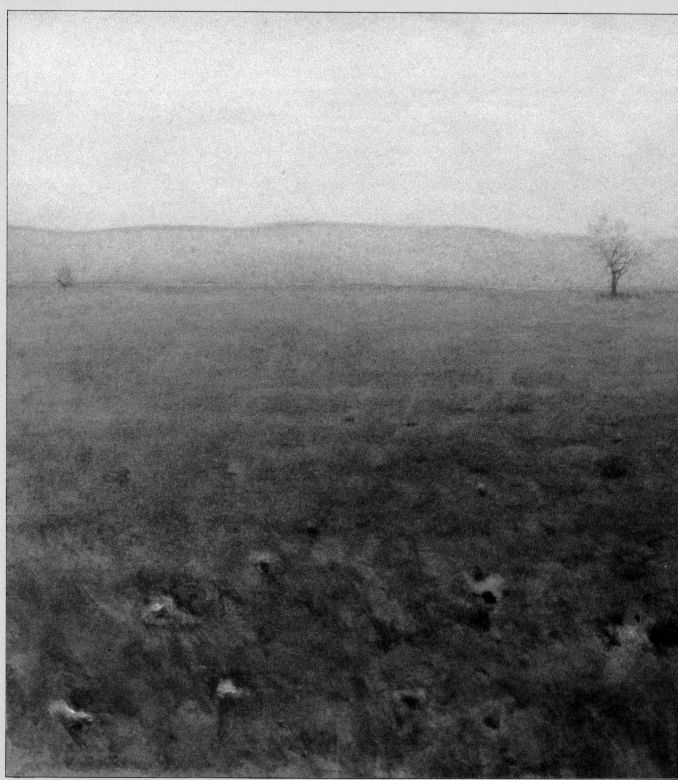

A HAYFIELD, *shown actual size, courtesy Wolfe Galleries, Tucson, Arizona.*

by Thomas Aquinas Daly

WATSON-GUPTILL
PUBLICATIONS
NEW YORK

TO MY CHILDREN:
Kathleen, Thomas, Ann Marie,
Christopher, Sean and Jonathan.

Note: The title for this book grew out of a one-man show of Thomas Aquinas Daly's watercolors at Grand Central Art Galleries, New York, in February 1983. Robert Preato, Director of the American Masters Department, called the show, "Nature's Quiet Places," and we found the title so evocative that we couldn't resist "borrowing" it for this book.

—*The Editors*

First published 1985 in New York by Watson-Guptill Publications, a division of Billboard Publications, Inc., 1515 Broadway, New York, N.Y. 10036

Library of Congress Cataloging in Publication Data
Daly, Thomas Aquinas.
 Painting nature's quiet places.

 Includes index.
 1. Watercolor painting—Technique. 2. Painting—Technique. I. Title.
 ND2420.D35 1985 751.42′2 84-25714
 ISBN 0-8230-3724-X

Distributed in the United Kingdom by Phaidon Press Ltd., Littlegate House, St. Ebbe's St., Oxford

Manufactured in Japan.

First printing, 1985

2 3 4 5 6 7 8 9 10/90 89 88 87

ACKNOWLEDGMENTS

There are several people who merit recognition for their assistance in the preparation of this book. First and foremost is my wife, Christine, who translated all of my diagrams, gestures, and broken phrases into intelligible text. Without her diligent efforts there would certainly be no book.

Special thanks are due to James Cox and his staff at Grand Central Art Galleries, especially Jeremyn Davern, who graciously gave of her busy time to help me assemble and properly credit the paintings reproduced herein. Similarly, the Keny and Johnson Gallery, Stremmel Galleries Ltd., Wolfe Gallery, and Ernie Saniga generously provided data and reproductions for print.

An expression of appreciation is due to Nancy Hengerer for faithfully and accurately typing the manuscript as it was fed to her in bits and pieces over the last year. And, I would finally like to thank Bonnie Silverstein and Candace Raney at Watson-Guptill for their patience and perseverence in dealing with a painter who insisted that he had neither the time nor the inclination to do a book. Through their gentle nudges, encouraging words, and guiding hands the job got done.

CONTENTS

HOLSTEIN HEIFERS, 8½" × 11⅜" (21.6 × 28.9 cm), *courtesy Grand Central Art Galleries, New York.*

INTRODUCTION

Whodels in my work that could be readily analyzed and translated
into text. I have little use for excessive verbiage about what I do, for I vastly prefer
activity to introspection. I like to work privately in my barn loft, removed from the
mainstream of the art world. I don't subscribe to any art-related periodicals and I
have minimal contact with other painters. Dissection of the delicate creative process
seems counterproductive, for such scrutiny could conceivably disrupt the natural
flow of my work as well as divert precious time. In actuality it did cripple me for a brief
while, and my painting became tight and self-conscious as a result.

Not one to pontificate, I don't feel that I have any answers to those who aspire to
learn from me. I am but learning myself, day to day and painting to painting. The
evolution is ongoing. The best that I can offer anyone in the way of information is to
convey how I feel about my pictures at this point in time. My opinions are not etched
in granite, for I may reverse them tomorrow if I should discover something new. I
endeavor to keep my mind and eyes open at all times for new ways to see new things.
Consequently, my appreciation of art is truly catholic and I can absorb influence
from any source.

I feel that I have just recently begun to develop my own visual language, after
many long years of study and practice. Now that I have assimilated a certain amount
of academic information and its implementation has become second nature, I feel
confident in allowing my intuition a freer rein. I firmly believe that a working
knowledge of the basic tools should be established before a painter can successfully
embark on a quest for a uniquely personal art. Once the factual material is
thoroughly digested, there is an internalized reservoir of reference material to guide
more inspired and original modes of expression. Having learned the rules, you then

have a license to break them, for repeatedly you will find that the reality of painting strays from painting theory.

My art is generally a mirror of my life experience, creating a visual diary of sorts. You can easily follow the seasons through my work and its subject matter. I am always attuned to my surroundings and I paint images as they present themselves. A still life with apples, for instance, is the result of a chance discovery of wild apples, as opposed to a consciously predetermined selection of subject matter. I spend a great deal of time outdoors fishing, hunting, and trapping because the assumption of my natural position in the biological order is a source of deep primal satisfaction to me. I don't consider myself apart from the natural world as a detached observer, but rather I am an active participant in it. It is from this perspective that I paint my pictures and aspire to convey the profound feeling that I have for my environment.

I strike a delicate balance between my work and play, for in a symbiotic way, one nourishes the other. When I am outdoors I am visually accumulating ideas for my art. When I return to my studio I feel refueled and eager to work. Conversely, my painting often recreates the circumstances of my outdoor activity, and I can once again savor the experience while working to recapture its essence.

Thus, my painting is so much an integral part of my existence that I find it difficult to isolate and scrutinize. It's woven into every facet of my life in some regard or another. It functions as a visual manifestation of my intangible self, communicated in paint because that is my language of preference. The task of further translating it into words has been awkward at times because visual imagery is infinitely less restrictive. Nonetheless, what follows is a sampling of my work. Some paintings are serene and idyllic while others may seem brutal and unsettling. They are all, however, real expressions from the heart.

INFLUENCES

PEARS AND CHICORY, 9½" × 6¼" (24.1 × 15.9 cm), *courtesy Grand Central Art Galleries, New York.*

As a young boy fervent about hunting and fishing, I eagerly pored over outdoor magazines such as *Field and Stream* and *Outdoor Life*. The illustrations of Bob Kuhn and C. E. Monroe, Jr., caught my eye and I emulated their wildlife illustrations. The work of sports magazine illustrator A. Lassell Ripley particularly impressed me, although at the time I really didn't know why. In retrospect, I realized that his work was more truly painting than illustration, and its sophistication sets it apart from commercial art.

During my college years, abstract expressionism was at its peak, and I was saturated in the work of Jackson Pollock, Clyfford Still, Willem de Kooning, Franz Kline, and Robert Motherwell. I became acutely aware of surface quality, and, as a result, the physical properties of paint. My subsequent venture into advertising shifted my focus toward simplicity, color, and, above all, design. Thus, the tightly rendered deer that embodied my notion of art as an adolescent succumbed to a whole new world of purely formal considerations. However, I had not yet developed a coherent perception of art history nor a true appreciation of painters and paintings.

I was several years out of school and removed from the artistic current when I happened to meet a painter, Bruce Kurland, who eventually became a friend. During the course of our friendship, he imparted an enormous amount of information, not only about other painters, but about painting in general. Kurland opened my eyes and stimulated years of hard work and learning in a way that my formal education had not. His exquisite still lifes as well as his vast stores of information and ideas were the catalysts that truly set the wheels in motion. It was primarily through Kurland that I became aware of numerous other painters whose works have also had a tremendous effect on my art.

Jean Baptiste Siméon Chardin's still-life paintings most definitely affected my ideas about subject matter. His poetic yet analytic pictures of hanging game and household objects conveyed a strong feeling for the beauty that is often overlooked in the commonplace. His restrained range of color and clear sense of spatial order were influential as well.

J. M. W. Turner's luminous, atmospheric paintings were particularly significant to me, especially his watercolors. His layers of thin transparent washes over white paper prompted his contemporary John Constable to describe his work as "airy visions, painted with tinted steam." That ethereal radiance is a quality that I strive for in lighting some of my landscapes. Turner also frequently depicted man as small and insignificant in the face of nature. This is a theme that permeates much of my own work.

John Singer Sargent and James McNeill Whistler both impressed me with their consummate skill in creating seemingly swift, unstudied compositions that were brilliantly subtle and carefully structured. Whistler's emphasis on pure formal harmony substantiates my own priorities in painting. In defending his work he

stated, "It is an arrangement of line, form, and color first, and I make use of any incident of it which shall bring about a symmetrical result."

When I discovered Albert Pinkham Ryder's haunting, mystical pictures, I was drawn away from a strictly analytical approach as I became cognizant of the powerful impact of freely expressed emotions and ideas. Ryder's eloquent honesty of vision has an appeal that far outweighs his lack of slick facility. The use of solid masses of form and color without superfluous detail gives his work an instinctive strength and vigor that I find compelling.

Winslow Homer probably had the most obvious influence upon my work. His background as a lithographer, like my own, made him keenly aware of using simple forms and broad masses to achieve the utmost visual intensity. He also obviously drew on his knowledge and imagination, as I do. Furthermore, his images of a solitary individual juxtaposed against an immense sea or wilderness created the same feeling I often convey in my own work. The lone fisherman or hunter seems to be at once a part of nature and apart from it.

I have also admired and felt myself to be influenced by George Inness, Thomas Eakins, Edward Hopper, Andrew Wyeth, and countless others. My work is in a constant state of evolution and my mind is always open to influences from any sphere. I am not such a staunch disciple of realism that I limit myself to a narrow corridor of appreciation. I extract what I find to be aesthetically and emotionally appealing from virtually any source and synthesize it into what I hope is my own unique vision.

A. LASSELL RIPLEY'S INFLUENCE

During my teens I would pore over the illustrations in sporting periodicals such as *Field and Stream* and *Outdoor Life*. Ripley's work in particular impressed me, as his treatment of the subject matter was unique. The sporting activity was often secondary to the landscape, an emphasis which was a deviation from the illustrative tradition, and that set him apart as more painter than illustrator.

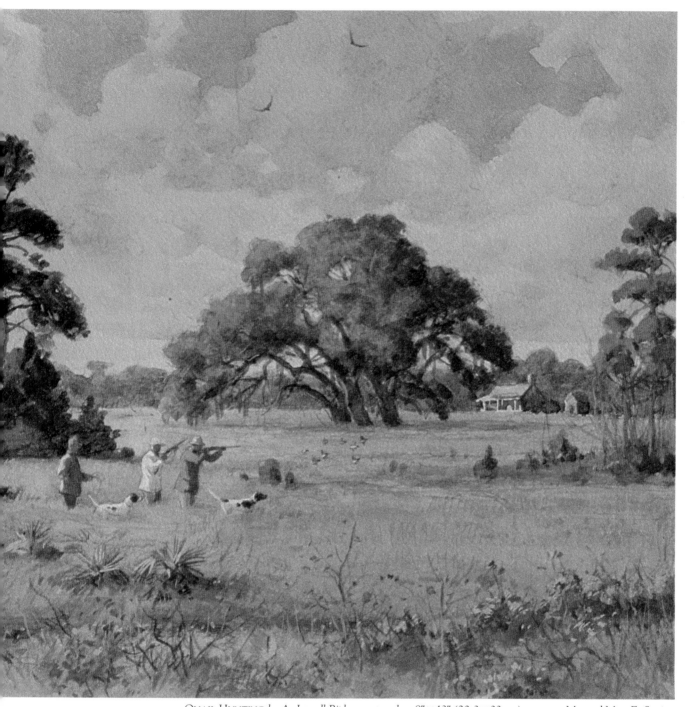

QUAIL HUNTING *by A. Lassell Ripley, watercolor, 8″ × 13″ (20.3 × 33 cm), courtesy Mr. and Mrs. E. Saniga.*

BRUCE KURLAND'S INFLUENCE

Whistler is representative of the type of work that Bruce Kurland was doing during the period when I came heavily under his influence. A dimly lit duck hanging by one foot against a dark background provides a jagged splattering of white plumage as its essential imagery. The subject matter and its dependence upon two basic values to create a clean and simple pattern are both ingredients that I have used in many of my subsequent paintings.

In *Three Sea Birds*, a later work, Kurland demonstrates the divergent path his art has taken since *Whistler*. After achieving a brilliant prowess in traditional still life, he chose to explore another dimension of his subject matter. In this painting the blank eyes and haunting grins of the bloodstained coot suggest that these birds may have been resurrected upon a tabletop. The same masterful use of color, paint quality, and composition are evident, but the reality is no longer of the tangible world. Kurland has utilized his traditional academic painting skills to express a macabre illusion with the implication that our conventional perceptions of reality are not necessarily universal.

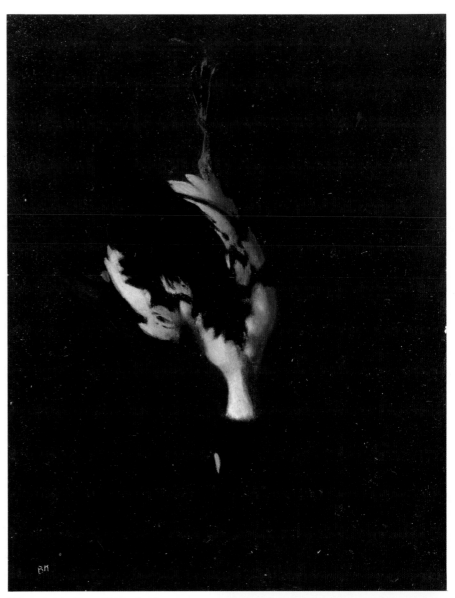

WHISTLER *by Bruce Kurland, oil on board, 8″ × 6¼″ (20.3 × 15.9cm), courtesy Thomas Aquinas Daly.*

THREE SEA BIRDS *by Bruce Kurland, oil on board, 16″ × 12″ (40.6 × 30.5 cm), private collection.*

AN EXAMPLE

A pair of hanging ducks offers an infinite array of design ideas for a still life, and I have produced numerous paintings of this subject. As an avid duck hunter, I collect representative male and female samples of many species and store them in my freezer for future use in picture making. The pair of wood ducks pictured here was shot over decoys in a cornfield at dusk, when the birds come in from nearby ponds for their evening feeding.

I find that the shape of ducks provides a compelling design element, and the interplay of light within their forms is equally fascinating. They are never randomly hung, and I sometimes spend hours arranging them in a pleasing pattern.

In this particular painting the composition rests on a series of parallel lines. For example, the cord suspending the birds' legs is parallel to the angle of the top bird's right wing, while its left wing remains parallel to the diagonal beam. The horizontal extension of the lower bird's wing repeats the strong horizontal at the top of the picture, and so on.

This composition depends heavily on its interesting negative space. The vast simplicity of the background wall provides a necessary contrast to the busy positive shapes (the ducks). On the wall at the lower right, I applied a faint dab of warm-toned paint to subtly balance the coolness of the rest of the painting.

The effect of the smooth rounded form of the birds' breasts was created by paying close attention to the edge planes, which are those areas or planes where there is a directional or shape change. Here, the plane that is turning toward the light is cooler, because it is reflecting less light than the plane that is perpendicular or closest to the eye. In a case like this, the edge plane can be either darker or the same value as it recedes around the form, but it absolutely must be *cooler*. In direct contrast to outdoor light on a sunny day, where the light is warm and the shadows are cool, indoor light is cool and the shadows are warm.

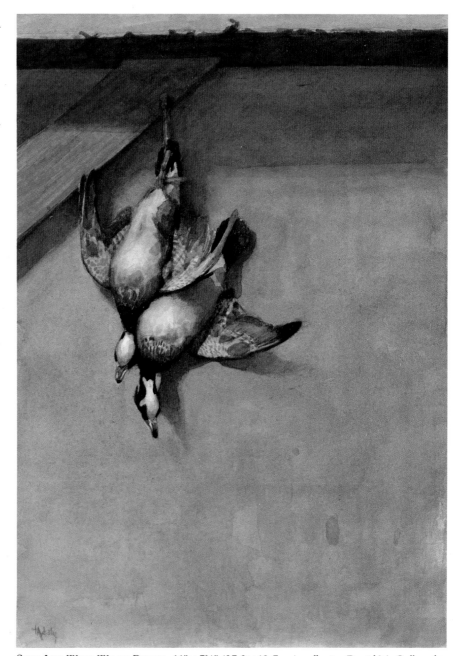

STILL LIFE WITH WOOD DUCKS, *11″ × 7¾″ (27.9 × 19.7 cm), collection Daniel M. Galbreath.*

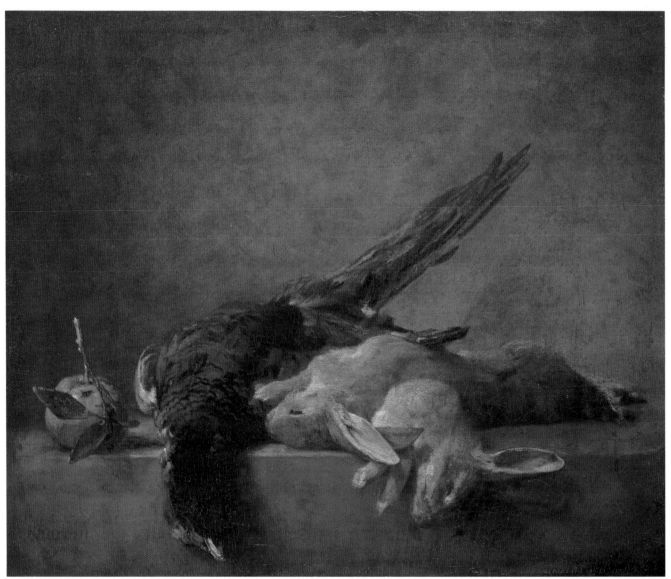

STILL LIFE WITH GAME, *c. 1760p–1765,*
by Jean Baptiste Simon Chardin, oil on canvas,
19½″ × 23⅜″ (45.5 × 59.3 cm), courtesy
National Gallery of Art.

CHARDIN'S INFLUENCE

The influences of other painters are notably at play in *Still Life with a Gray Fox.*
The use of dead game in still life reflects the tradition of Chardin and William
Harnett. The horizontal beam support for the fox can be directly attributed to the
influence of Bruce Kurland. However, paramount in importance is that the
composition is firmly rooted in twentieth-century geometric abstraction.

The strong, angular composition of *Still Life with a Gray Fox* was a compelling
force throughout its execution. After trapping a gray fox and hanging it up to be
skinned, I suddenly became aware of the visual sensation created by the triangular
shape of the animal in this position. The fox was subsequently taken to my studio
and suspended from a diagonal beam, and the composition immediately came
together. A series of triangles emerged, creating one of the most interesting spatial
divisions in any of my paintings.

The white clamshells in the painting were included to balance the
composition, although in retrospect I probably didn't need them. However, I used
their oval shapes and light value to echo the same shapes and values on the fox's
head and ear. Balancing a composition is less important than creating an
aesthetically interesting two-dimensional design.

The texture of the fox's coat is the result of careful attention to the treatment of
edges, as opposed to rendering the details of hair. Where light meets shadow
within the fox's body or where the fox hairs meet the wall, I kept the edges soft,
as fur blurs the reflection of light to the eye.

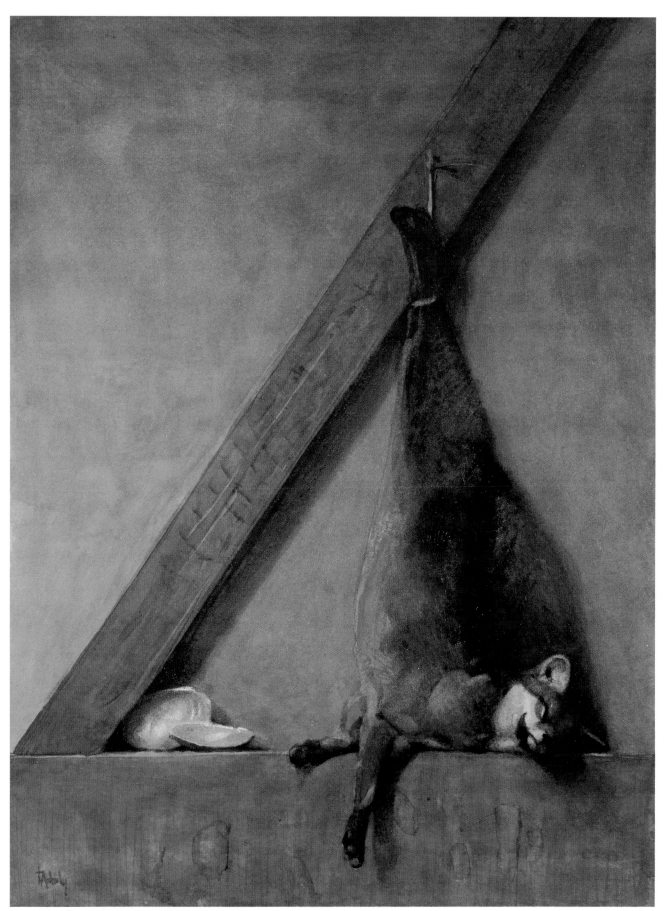

STILL LIFE WITH A GRAY FOX, *12¾″ × 9½″ (32.4 × 24.1 cm), collection Jack Parker.*

AN EXAMPLE

Capturing the delicate coral-colored flesh of a fresh Atlantic salmon was my primary motive in creating this particular painting. I maintained it as the picture's focal point, surrounding it with neutralizing blues and grays. The cool, shimmering metallic kettle provides a strong contrast to the soft warmth of the fish, and, as always, these subjects were carefully arranged before I began work. The ring and connected string that hang on the background wall appear in several of my pictures, and they were added to this one as an afterthought. They served to interrupt the negative field as well as to echo the shape of the onions. All of the composition's positive elements are fused into one mass with the exception of the dangling string, which creates a tantalizing tension in relation to the spout of the kettle.

The traditional still-life arrangements of Chardin were an obvious source of influence in this work. His pictures of pots and kettles accompanied by vegetables and slabs of meat often included an element that broke up the edge of the supporting table or ledge. Here I used the dangling skin of an onion for that purpose. While Chardin's background walls gradually fill with light from left to right, my lighting is dictated by the illumination in my studio. Although the directional source is the same as in Chardin's paintings, my light fades as it nears a corner to the right.

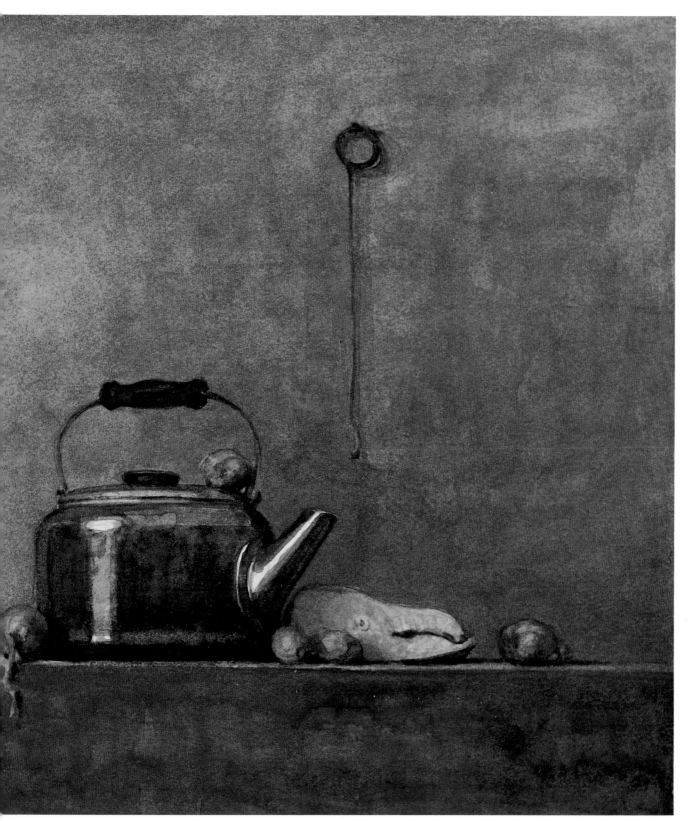

A Slice of Salmon, *shown actual size, collection Lawrence Eno.*

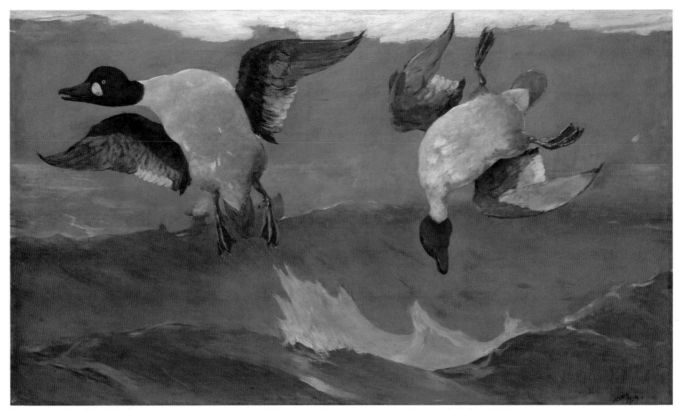

RIGHT AND LEFT, *1909, by Winslow Homer, 28¼″ × 48⅜″ (71.8 × 121.9 cm), courtesy National Gallery of Art.*

WINSLOW HOMER'S INFLUENCE

Although I wasn't cognizant of it at the time I executed this piece, *Death Dance* closely parallels Winslow Homer's *Right and Left*. Both paintings depict a fallen bird in the immediate foreground, with a hunter in his boat receding into the background atop a diagonal sweep of sea.

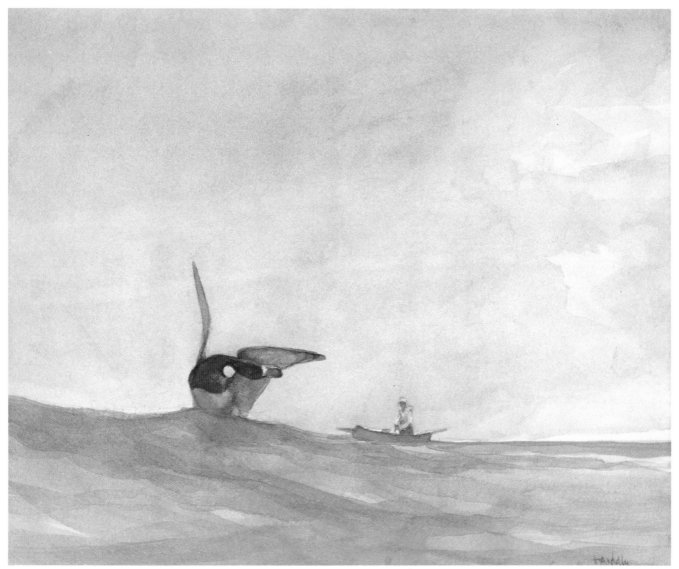

DEATH DANCE, 7⅜″ × 9¼″ (18.7 × 23.5 cm), *collection James Jennings.*

AN EXAMPLE

Because of its macabre subject matter, *Death Dance* generates a considerable degree of controversy. While most of my paintings that describe aspects of a hunt focus on the tranquil, reflective moments, this one is atypical in its drama, depicting the contortions of a dying bird. The strong directional thrusts of the writhing duck's wings starkly silhouetted against the expansive sky create a compositional tension that augments the high emotion of the subject matter.

Although the death of a bird is a common spectacle while hunting, I chose to depict it from an unconventional point of view. It is represented here as no hunter would really perceive it: from the imagined vantage point of another duck on the water.

The original concept for *Death Dance* grew out of my still-life paintings of hanging ducks and the dynamic shapes they create; and as a prelude to this painting, I did several drawings of contorted birds from memory. Originally, I intended to show a duck alone, but the hunter and boat were added in order to lend the picture a narrative quality. In retrospect, the drawing of the bird seems inaccurate, but the beauty of its shapes remains and successfully creates the strong statement I sought.

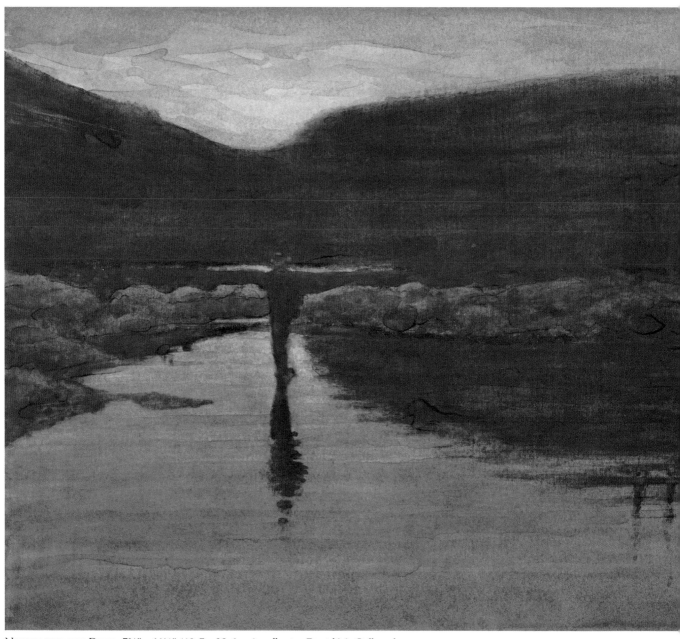

NEWFOUNDLAND DUSK, *7¾" × 11¼" (19.7 × 28.6 cm), collection Daniel M. Galbreath.*

ALBERT PINKHAM RYDER'S INFLUENCE

There is a sinister, ominous quality to *Newfoundland Dusk,* where a lone fisherman is seen silhouetted against a stark Newfoundland river at dusk. Because of the limited color and value range, I made a considerable effort to create the right harmony between the dark gray masses of the land and reflections and the pink of the sky and water. The vertical shape of the man standing on a rock and his reflection basically repeats the larger horizontal shape of the land masses.

This picture is somewhat different from my other work in the coarse, heavy way in which it was handled. The figure is crude and primitive, but the shape it creates felt right to me.

There is nothing academic and disciplined about the drawing in this piece. Instead, the pervasive mood was emphasized through the use of heavy dark shapes and a very limited palette.

The influence of Albert Pinkham Ryder is quite evident here in the crude, mysterious tenor of the work. It's almost dreamlike, based on instinctive feeling more than logic and precision. As in Ryder's work, there is an absence of detail "to vex the eye." It is a simple, strong statement of nightfall in the harsh, remote, and rugged interior of Newfoundland's southern coast.

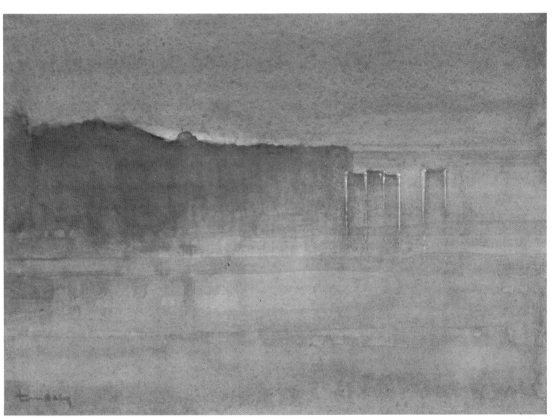

WHITEFISHING BOATS, CRYSTAL LAKE, MICHIGAN, *5″ × 6¾″ (12.7 × 17.2 cm), collection Demetrius Alfonso.*

JAMES McNEILL WHISTLER'S INFLUENCE

In early spring, I often travel to northern Michigan to fish the small rivers for trout. On a calm evening at nearby Crystal Lake, the small congregations of boats with lanterns at each end piqued my interest. I came to learn that these boats were used for whitefishing, and I was compelled to stop and make several sketches.

Upon returning home, I quickly painted *Whitefishing Boats, Crystal Lake, Michigan.* It was an unusually simple endeavor, completed in little more than one application of washes. The vertical streaks of light reflected on the tranquil surface juxtaposed with the horizontal silverlike boats created a particularly appealing image that I intend to use again in another piece.

This specific painting is vaguely reminiscent of Whistler's nocturnes. While his influence was not consciously in mind when I painted it, I have always been inspired by his work. Whistler's dedication to pure formal harmony and his subtle skill in composition are qualities that I find to be notably superior. Although his compositions appear to be casual at a glance, they are in actuality fastidiously structured. Whistler's frequent use of waterfronts shrouded in the veil of night interspersed with flecks of light was a common vehicle for this primary end. I have used similar subject matter in this painting to achieve my foremost objective—a well-structured two-dimensional design.

THE INFLUENCE OF GEORGIA O'KEEFFE AND ANDREW WYETH

A longtime hunting crony of mine triumphantly appeared at my door last fall with a large buck to be butchered. He wanted to mount the rack for posterity and left the head in my barn for that purpose. My immediate impulse was to paint it. With its beautiful, ready-made pattern of line and mass, I felt that it would be an outstanding subject. However, I instantly had some misgivings, since I thought it might be interpreted as a subject selected solely for its shock value. I struggled with this conflict for a while, until I got my priorities into the right perspective. Then I began to paint.

I thought it was important to arrange the picture in a way that would convey what the subject really was: not a trophy mount, but a deer's head. It had to be believable, so I placed the head upside down on a beam with the tongue protruding.

One of the best reasons for using this deer's head as a subject was that it provides a beautiful array of curves, shapes, and textures from every angle. The linear pattern of the antlers and the mass of the head and ears lent themselves naturally to a two-dimensional design. I cocked the head in such a way that one stark antler worked in conjunction with the head to break up the light value of the wall, while the lower antler served to interrupt the dark mass created by the supporting beam.

The use of skulls and antlers in the still-life paintings of Georgia O'Keeffe and Andrew Wyeth has always captured my interest and that influence came to fruition in *Head of an Eight-Point Buck.*

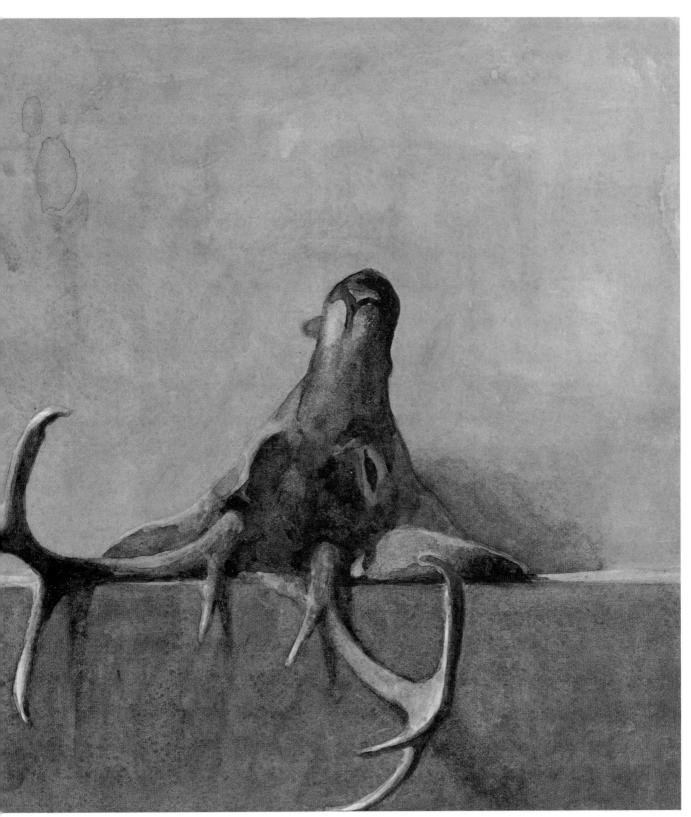

HEAD OF AN EIGHT-POINT BUCK, *shown actual size, collection Daniel M. Galbreath.*

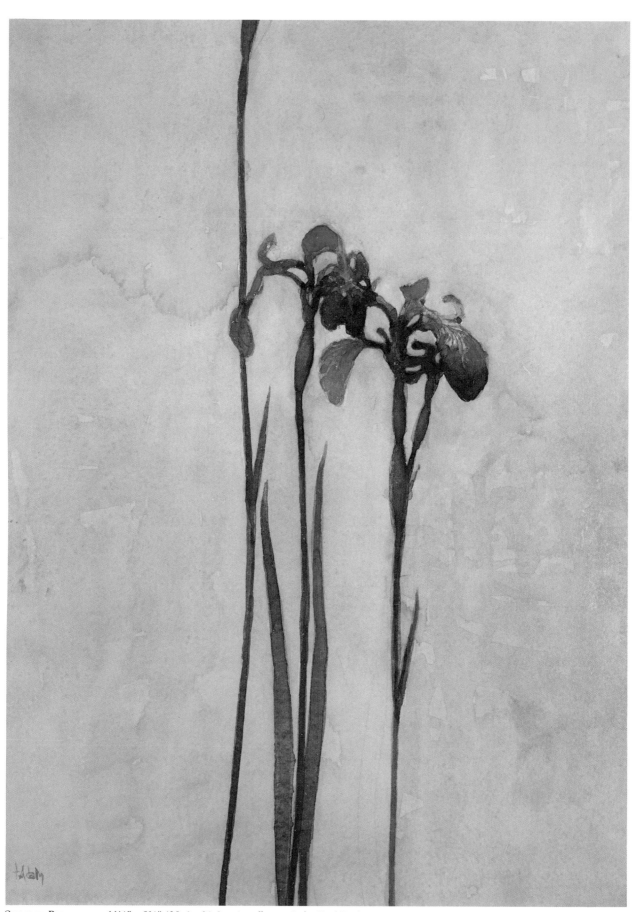

SLENDER BLUEFLAGS, *11¼″ × 8⅜″ (28.6 × 21.3 cm), collection Judge Paul Buchanan, Jr.*

THE INFLUENCE OF JAPANESE ART AND ART NOUVEAU

In early summer I spend a good deal of time seeking prospective trapping territory for the upcoming fall season. In June the wild blue flags bloom in the shallows of the marshes. The delicate flowers lend themselves naturally to a linear abstraction, with beautiful interlacing curves and tapering vertical leaves and stems.

Slender Blue Flag is strongly influenced by Japanese floral prints, with their powerful simplicity. Instead of using the flowers as one of several elements within a still life, I chose here to close in on them, making them the sole subject and allowing them to extend beyond the picture's edges.

This is basically a two-value picture, with the brilliant flowers superimposed on the neutral background to create a bold, flat pattern. The only variations within the dark value are essentially those of hue and chroma. To achieve the intense, saturated color of the flowers, I basically used pure, clean color (ultramarine and Prussian blue) right out of the tube. The touch of turquoise paint that outlines the edges of the petals was slightly diluted with water.

The structure of the image was carefully calculated to enclose interesting areas of negative space. Like many Japanese prints, the composition is off-balance, and the emphasis is on the synthesis of form and color into a semiabstract image. Because this picture is more dependent on line than masses, I strove for a sensuous elegance of line, almost art nouveau in character.

DETAIL

The textured, mottled ground not only indicates that there is something behind the flowers, but its painterly execution also creates interest in itself.

The neutral background tone here was created by a series of six or more washes. I typically begin these background washes with a diluted wash of warm, light color, such as a mixture of cadmium orange and alizarin crimson. Then to cool down the warm color, I wash over the initial layer with a tint of ultramarine blue. I continue applying these layers until I arrive at what I think is just the right temperature for the background.

COMPOSITION:
the underlying abstraction

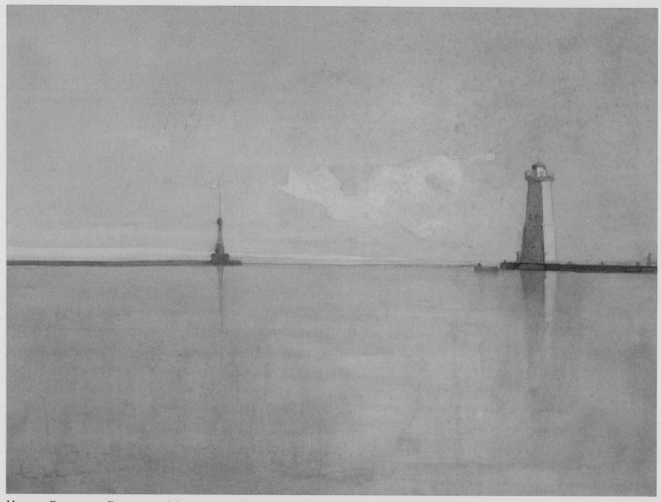

HARBOR ENTRANCE, FRANKFORT, MICHIGAN, 6⅜" × 9" (16.2 × 22.9 cm), *courtesy Thomas Aquinas Daly.*

Composition is certainly my foremost priority in developing a painting. The basic academic principles of balance, movement, repetition, and unity form the obvious cornerstone; however, I have developed enough confidence in my own instinct for design to free myself from a servile adherence to them.

The single most notable attribute of my picture making is my compulsion for simplicity. My background in advertising design impressed upon me the importance of breaking a statement down to its simplest components in order to achieve the maximum visual impact. Sharp, incisive divisions of space attract the eye from afar, which can be of additional import when work is small in format.

Most of my still-life arrangements consist of a single dynamic shape within a vast negative field. The shape may consist of several objects and their cast shadows, but they are all generally massed together as a unit. For instance, in the watercolor *Rabbit and Apples* (see page 39), the rabbit, shelf, and apples are all physically connected to create one primary shape.

Since it is the foundation of my composition, the shape that I select is of key importance. I am acutely aware of shapes in everything that I see, from coffee stains to blobs of paint on my palette. Once a shape has captured my attention, I go about the mental process of selecting a subject that can be worked into it. My initial impetus is therefore similar to composing a purely abstract two-dimensional design. But because I'm a representational painter, I face the additional challenge of selecting a subject from nature and adapting it to the shape that I have in mind. This is often the most stimulating, as well as perplexing, aspect of my job.

Once I decide what the positive shape will be, I look at the negative space around it. It may be either expanded or cropped in order to reach a satisfying balance. When you have the visual weight of color, form, and texture massed together in one area, the eye needs a great deal of relief in the surrounding space in order to achieve equilibrium. While I rarely aim for a formal balance, I intuitively try to find a composition that will equalize the visual weights of the positive and negative spaces.

After the basic arrangement is established, I take great care in selecting my values, always maintaining a clear distinction between what belongs to the positive shape and that which belongs to the surrounding negative space. There is a finite range of values within each, and forms must be built up within those limitations. In order to maintain the strength and simplicity of my design, it is imperative that I sustain a well-defined separation between the two areas at all times.

Thus, the simplicity of my still-life compositions emerges from a complex series of choices. There is a steady sequence of intuitive judgments that are made as a picture evolves, constantly purging the redundant details and clarifying its essence.

My landscape paintings evolve in much the same way. A recurrent characteristic of many of them is the implementation of strong horizontal elements. By dividing

the picture plane into a few strategically placed bands, the design is immediately sharp and simple. This gives the picture prominence at a distance and compels the viewer to move in for a closer look. The simple divisions then become more complex, as I will often scatter additional points of interest within a space (see *Orleans County Landscape*, pages 34–35) or create an appealing edge (see *Moose Hunter*, page 36). Occasionally I will pursue a decorative tangent, working in lyrical patterns with opaque color to create a subtle ornamental quality that is only apparent upon close scrutiny. All of these lesser elements give the viewer something extra to play with, involving him or her directly in the discovery of more than he or she initially perceived.

I establish the values within a landscape composition by breaking it up into the planes that will inherently dictate the values. The sky-reflecting planes of ground and water usually constitute the light values while the uprights of woods and walls function as the dark masses (see *Bass Fishing on the Genesee River*, page 37). Trees and other vertical forms are seen as darker because light hits only the tops of these objects. I seldom concern myself with the intricacies of form unless I should happen to have an object in the immediate foreground. Most often, however, I deal in large expanses, attending to the intrinsically beautiful shapes of fields, woods, and water.

Thus, if my paintings possess strong design, it is derived from the power of simplicity. My prevailing format consists of a single dynamic shape and its strategic placement within the bounds of the picture plane. Occasionally I will deviate, as in *Harbor Entrance: Frankfort, Michigan* (see page 28), and include two or more shapes and play upon the tensions and relationships between them. I try to maintain an open mind and experiment from time to time; however, my personal visual preferences continue to draw me back to similar modes of spatial organization. I don't feel that my propensities are either superior or inferior to anyone else's. They are simply mine, a reflection of my own aesthetic sense of order.

SPRING PEEPERS

In early spring, when the first hints of grass are breaking through the soft wet earth, tiny frogs called spring peepers create a welcome din at twilight. I take the opportunity to relax and drink in the spring transition, as autumn usually races by with all of my hunting and trapping activity. This picture depicts one of the little brooks where I trap mink as it appears in late April. I have created an austere composition dependent upon patches of reflected sky arranged against a barren field.

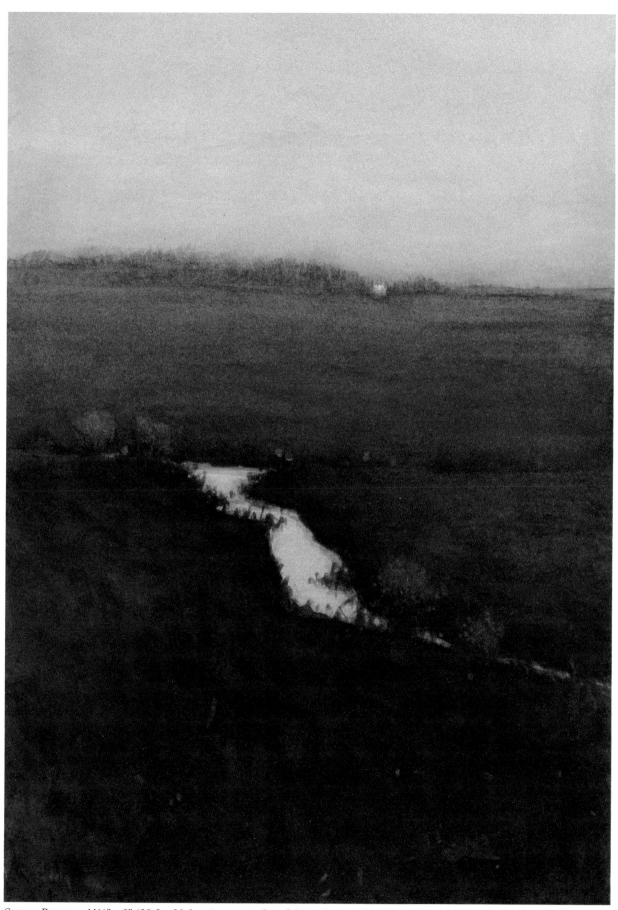

SPRING PEEPERS, *11½″ × 8″ (29.2 × 20.3 cm), courtesy Grand Central Art Galleries, New York.*

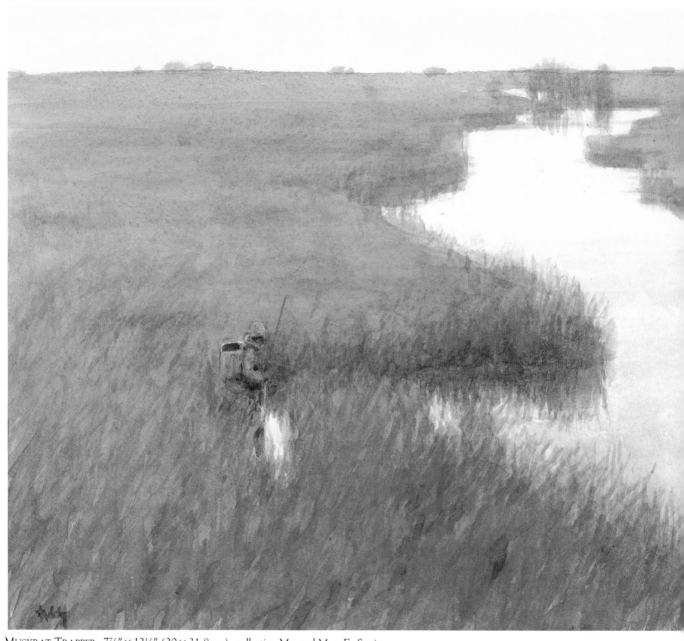

MUSKRAT TRAPPER, *7⅞″ × 12½″ (20 × 31.8 cm), collection Mr. and Mrs. E. Saniga.*

MUSKRAT TRAPPER

The use of aerial perspective to describe receding space is clearly exemplified in *Muskrat Trapper.* The autumn's dead marsh grass is cooled significantly as it is increasingly enveloped by atmosphere. The basic composition is stark in its simplistic division between the land mass and the light value of the sky and water. The ideal is totally a product of my imagination, for here I have indulged a longtime fantasy of trapping in a huge marsh. Marshes such as this are virtually inaccessible to most people because the trapping rights were established long ago by previous generations.

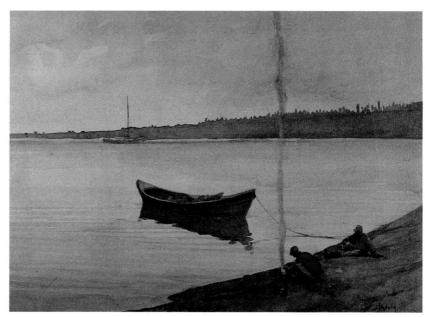

TEA, *8¾″ × 12¼″ (22.2 × 31.1 cm), collection Jack Parker.*

TEA

Tea was painted as a reminiscence of a fishing trip to the Newfoundland coast. I have employed the double-ended boat as a dominant crescent shape within the composition. Two vertical elements emerge at either end of the boat, interrupting the picture's horizontal bands to create a geometric grid.

"A recurrent characteristic of my landscape paintings is the implementation of strong horizontal elements. By dividing the picture plane into a few strategically placed bands, the design is immediately sharp and simple."

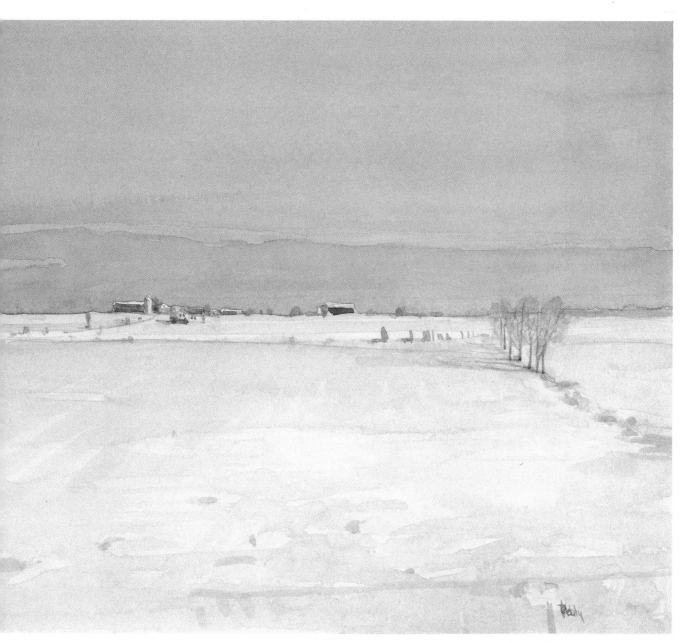

ORLEANS COUNTY LANDSCAPE, *shown actual size, collection Daniel M. Galbreath.*

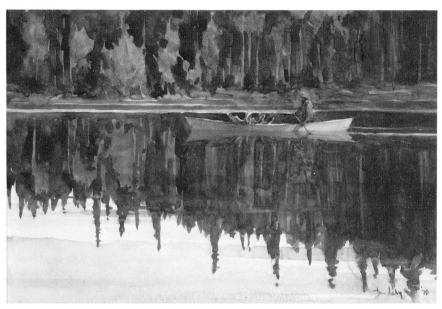

MOOSEHUNTER, 6¼″ × 9½″ (15.9 × 23.5 cm), *collection Daniel M. Galbreath.*

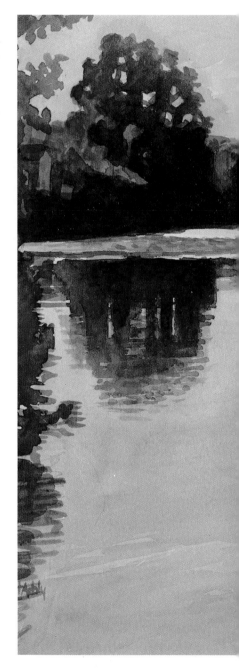

"I establish the values within a
landscape by breaking it up into
planes that will inherently dictate the
values. The sky-reflecting planes of
ground and water usually constitute
the light values while the uprights of
woods and walls function as the
dark masses."

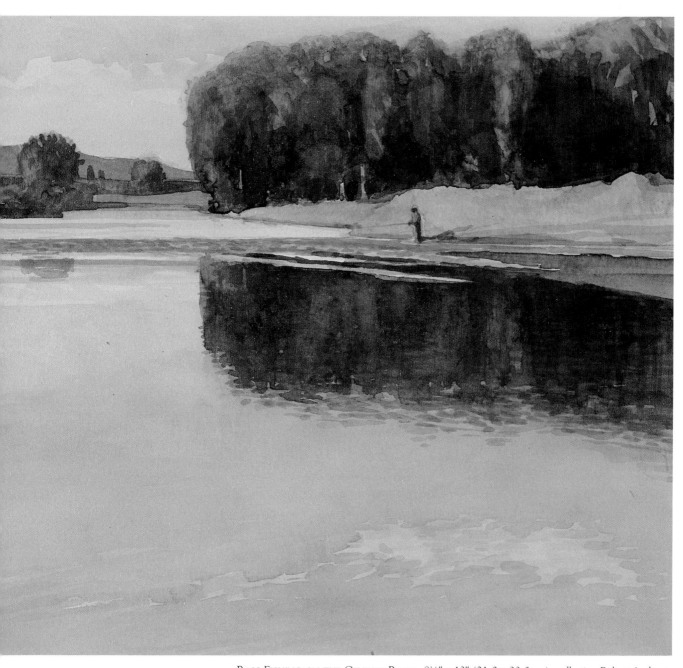

BASS FISHING ON THE GENESEE RIVER, 8¼″ × 13″ (21.0 × 33.0 cm), collection Robert Anderson.

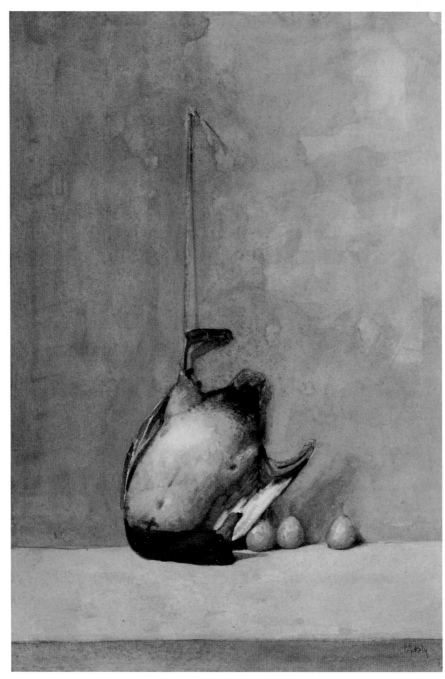

A Northern Bird with Three Pears, *12″ × 8⅜″ (30.5 × 21.3 cm), collection Jack Jeffrey.*

ABSTRACTING FROM LIFE

As in any of my still-life paintings, the elements of these compositions could have been successfully arranged in a myriad of ways. I perpetually cull out extraneous clutter until I attain the minimal statement that can still carry the nucleus of the picture's concept. Emerson once stated, "All great actions have been simple and all great pictures are." And I wholeheartedly agree.

My original notion in *A Northern Bird with Three Pears* (above) was to capitalize on the striking coloration of a greater scaup drake. The bird's sharp black and white plumage is accented by its handsome blue-gray bill and feet; these colors are then complemented by the russet pears and ochre wall. Because the picture is weighted heavily toward the bottom, the linear string and foot were implemented to break up and provide a balance for the upper negative space.

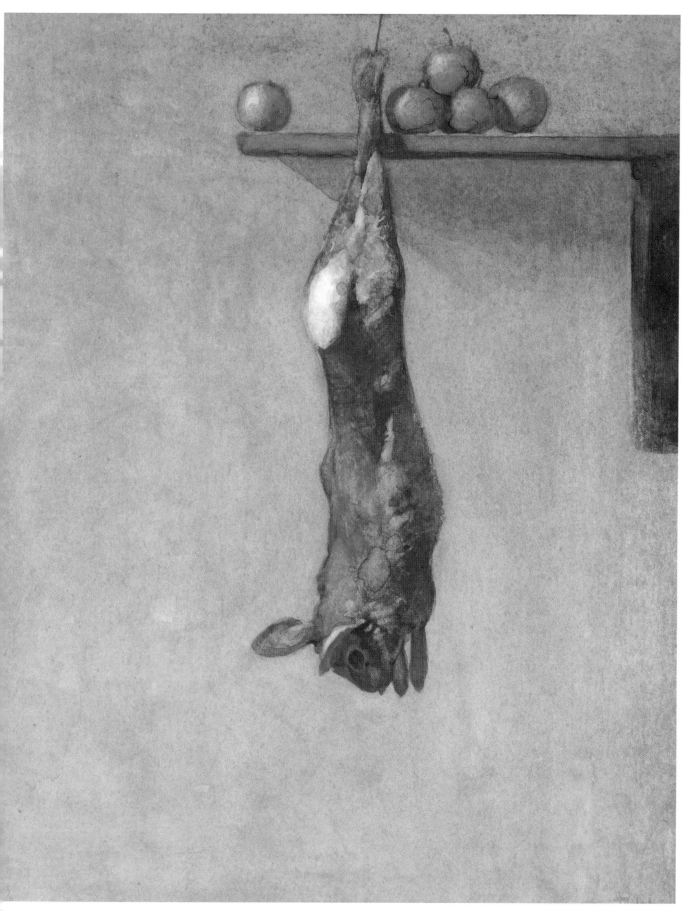

RABBIT AND APPLES, *10⅜″ × 8¼″ (26.4 × 21.0 cm), collection Daniel M. Galbreath.*

SETTING UP A RHYTHM

In arranging a composition I will often rely on the repetition of similar elements to create a sense of unity. Establishing such visual rhythms is a very basic organizational principle based upon a readily perceived order. By creating a pattern of elements that share one or more characteristics, you can lead the viewer's eye on a visual search, of sorts, through the picture.

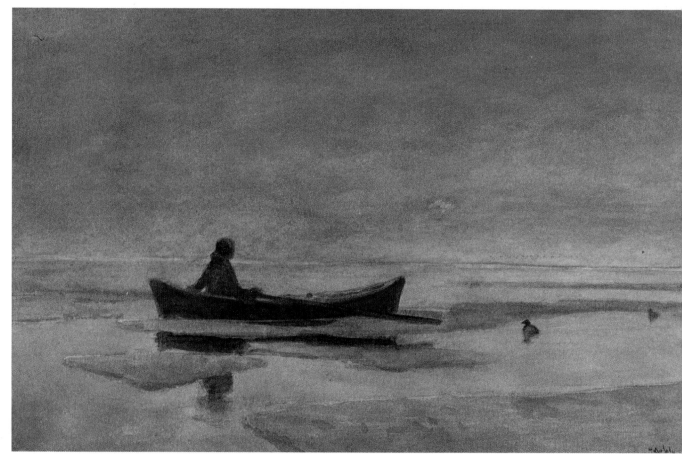

GUNNER AND FLOATING ICE, *7⅝″ × 12″ (19.4 × 30.5 cm), collection Mr. and Mrs. E. Saniga.*

GUNNER AND FLOATING ICE

This painting relies on a more subtle use of repetition, because the shapes and proportions of the hunter and decoys don't obviously replicate one another. Nonetheless, the faint similarity of shapes is sufficient to function in the establishment of a brief rhythmic skip back into receding space.

THE HOGSBACK

In this picture I employed an active weave of repeating diagonal and vertical bands. A few strategic horizontals carry the major spatial divisions and focal point. While there is not a dramatic variation in values, the interplay among strips of cool against warm (and vice versa) makes the picture dynamic and vibrant. On the edge of the open space where the linear interaction has ceased, the deer has been placed to break up the negative space of the lower right side of the painting.

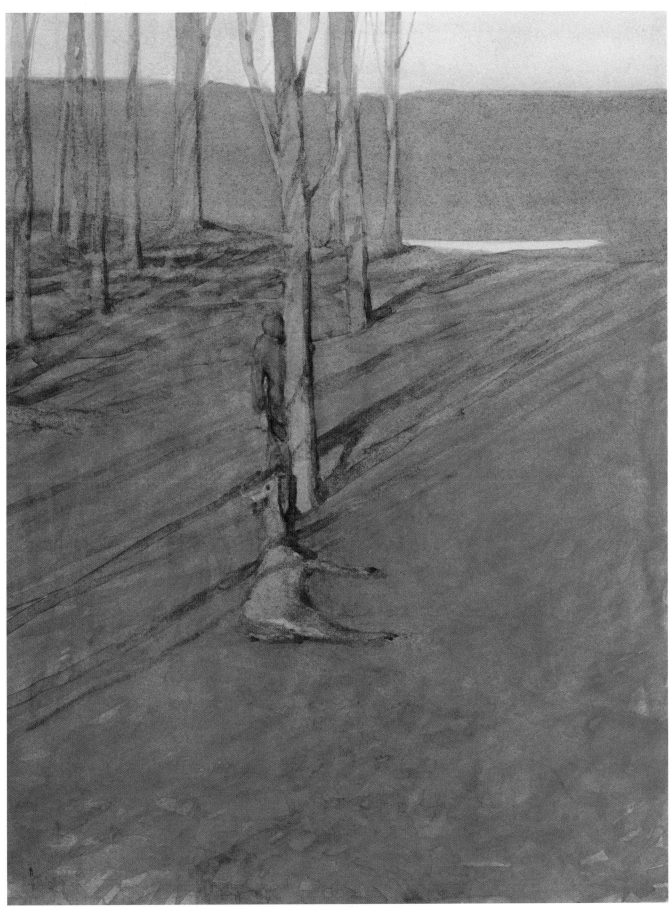

THE HOGSBACK, *10½″ × 8″ (26.7 × 20.3 cm), collection Mr. and Mrs. Peter Stremmel.*

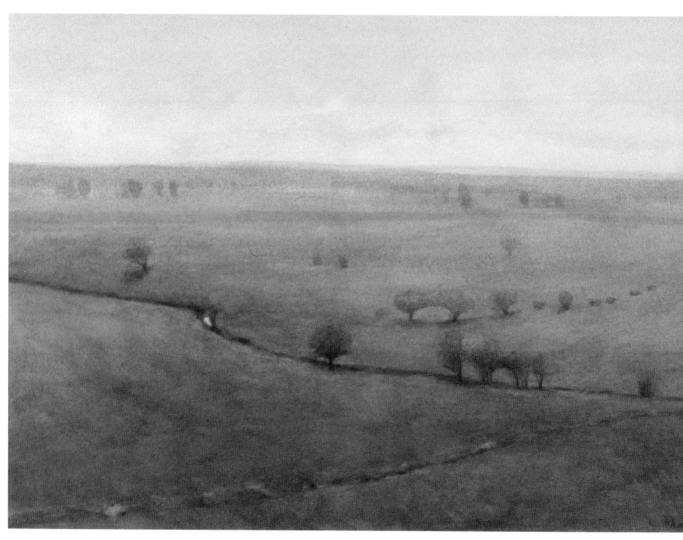

WEST PASTURE, 8½″ × 12″ (21.6 × 30.5 cm), courtesy Wolfe Gallery, Tucson, Arizona.

EAST PASTURE and WEST PASTURE

This pair of paintings was an unusual departure for me in that I painted a continuous panorama in two parts. They were developed to stand alone as individual paintings but also to function as a diptych. In both of them I have used the same size and shape trees in a staccatolike pattern to give interest to an extremely simple composition. I have also used a linear grouping of trees to echo a furrow in the terrain.

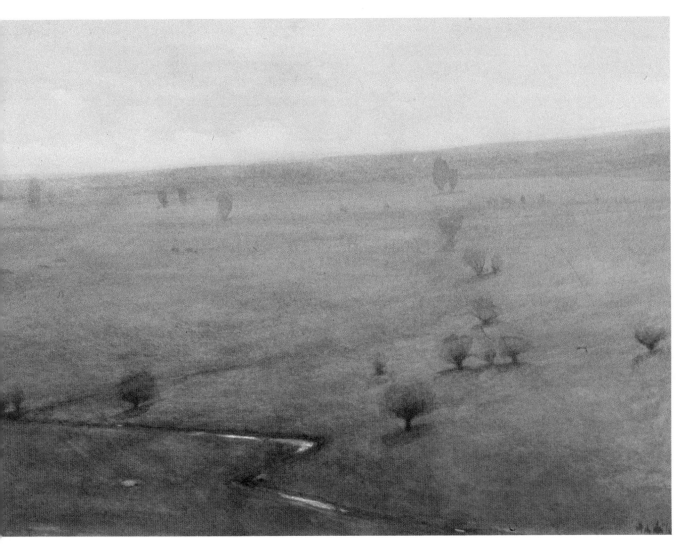

East Pasture, 8½″ × 12″ (21.6 × 30.5 cm), courtesy Wolfe Gallery, Tucson, Arizona.

Balancing Values and Masses

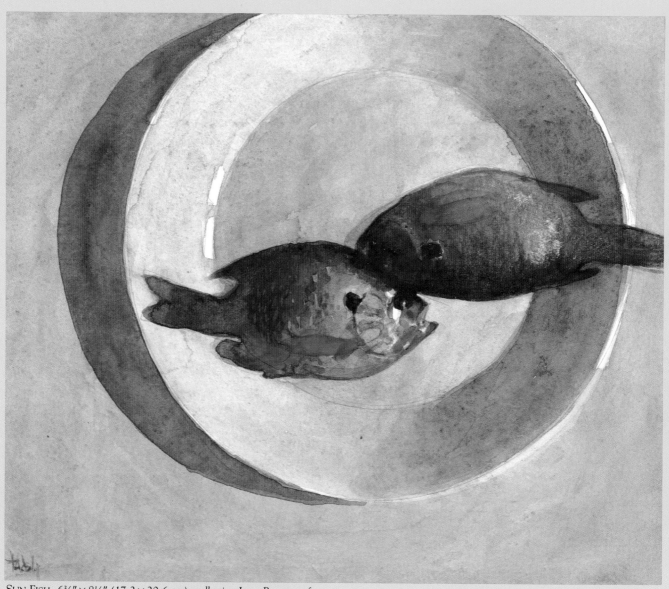

SUN FISH, 6¾″ × 8⅛″ (17.2 × 20.6 cm), collection Jerry Ravenscroft.

A hue or value can never be appraised in isolation, out of the context of the painting as a whole. They are all interdependent and relative, relying upon one another to function as an aggregate. For instance, the value that depicts a brilliant sunlight in one picture can function as the value of an entire overcast sky in another. A specific value is only as light as the surrounding values dictate it to be.

There is no way that a painter can literally light up a painting. You have at your disposal a finite range of values from black to white from which you can create only the *illusion* of light. Consequently, white paint or the white paper must suffice to represent the most brilliant illumination.

It is important to establish the picture's middle value before beginning to paint. This is in part dictated by your subject matter. If you were to include, for example, a silver bowl in your arrangement, it would be necessary to accommodate shining highlights and then build a scale of values down from that point. No other value in the picture could be as light as that metallic highlight, not even the lit surface of a white object, such as an egg. By thinking these relationships through in advance of painting, you can eliminate a great deal of frustration and juggling during the actual process.

One aid in selecting and correlating my values in oil painting is built right into my palette. I work on a clear piece of glass placed on top of a neutral, middle-value gray panel. I can then compare the values I'm mixing to that gray panel. Additionally, when I paint in oil, I tone my panels in raw umber at a middle value. When I use watercolor, I work directly from the white paper, though many painters find it helpful to tint their papers a light value first to get rid of the glaring white. None of these frames of reference assure an easy selection process; however, they can provide some minimal guidance in properly integrating value choices.

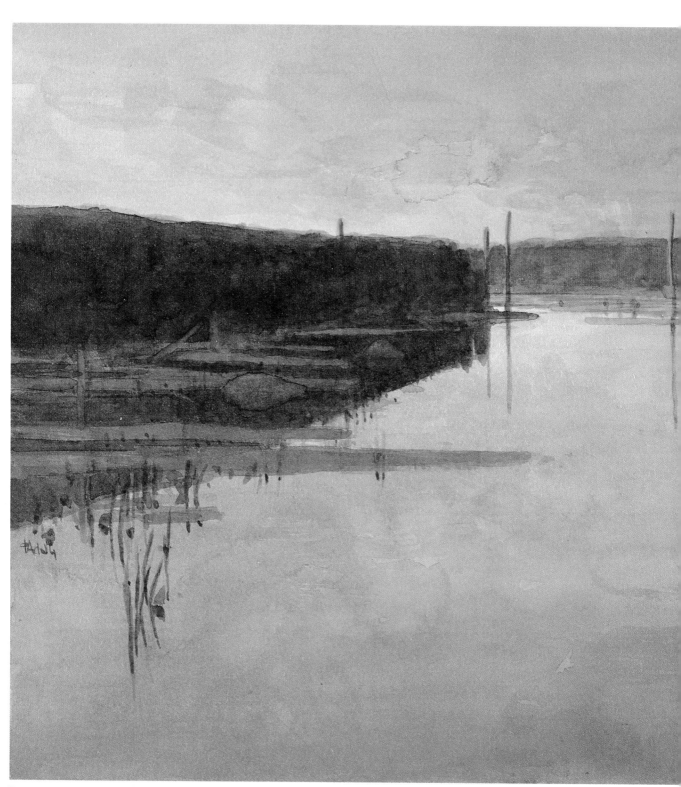

Centerville Rat Houses, *shown actual size, collection Daniel M. Galbreath.*

CENTERVILLE RAT HOUSES

The pond depicted here was created by a beaver dam that flooded a creek into the adjacent woods, leaving the towering dead trees that serve as vertical elements within this basically horizontal image. About a year after the area flooded, the muskrats moved in and constructed their domed houses in the shallows out of cattails, marsh grass, and sod.

The major elements within this composition are two land masses in low sun—one in the light and the other in shadow. While the shapes complement each other, the difference in tone tips the weight of the picture toward the dark mass on the left. Thus the placement of the opposing oval created by the muskrat house in shadow and its reflection were used for balance. The verticals created by the dead tree trunks in sunlight are repeated in the lower left by weeds in shadow.

The most difficult problem in this picture was understanding the values within the shaded mass. The protruding fingers of floating weeds interrupt the dark reflection of the land and are comparatively lighter in value. They had to be treated as horizontal planes lit only by the dark blue sky directly overhead.

The interplay of warm and cool is also dictated basically by light and shade. Intensified somewhat by the low sun, the areas in direct light are warm and the shadows are cool. The sky overhead is dark and cool and becomes lighter and warmer in the distance. This same effect is mirrored in the water. (Generally speaking, white and blue colors usually appear warm at a distance.) Thus, because the eye is almost tunneled toward the warm glow near the picture's center, an illusion of depth is achieved.

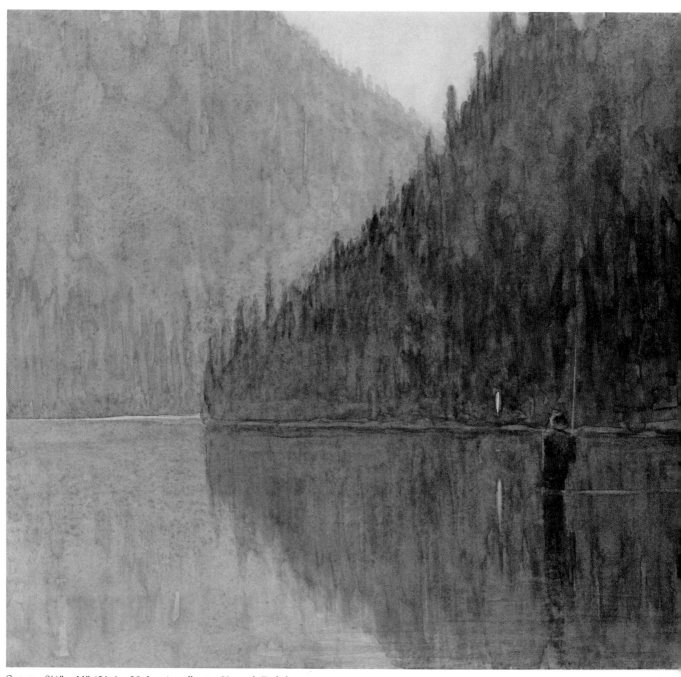

SALAR, 8½″ × 11″ (21.6 × 28.0 cm), collection Kenneth Endick.

SALAR

The Latin name for the Atlantic salmon is *salmo salar*, which roughly translates to "the leaper." Thus originated the title of this picture depicting a jumping salmon on a Newfoundland River.

This composition is the ultimate in simplicity, depending on big divisions of space for its power. The tall vertical shapes of the spruce trees that parallel the salmon and its elongated reflection serve to accentuate the fish's skyward leap. The small triangle of sky points directly to the fish, directing the eye to the picture's focal point.

This painting is a careful study in values. Because the picture's masses are so huge and simple, a delicate balance of values was critical. As small as the salmon is in relation to the massive landscape surrounding it, its high value is what makes it stand out as the single most important element in the picture. The fish's silvery surface allows it to mirror the sky and endows it with the painting's lightest value. This example serves to emphasize the critical importance of value selection; by being slipshod, a painter can unintentionally give prominence to the inconsequential elements of a picture.

The execution of this painting was a simple series of washes, the primary task being the careful forethought in selecting the appropriate values to make the huge shapes read coherently. My basic belief is that most good compositions are simple and direct, relying on a minimum of clean, strong shapes for optimum visual impact.

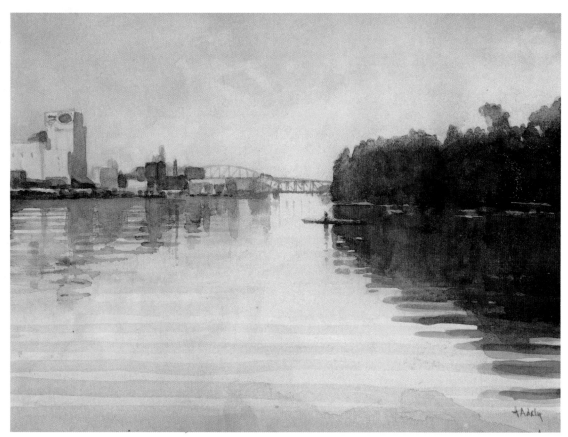

BLACK ROCK CANAL, *6″ × 8¼″ (15.2 × 21.0 cm), collection Lois Wagner.*

BLACK ROCK CANAL

This is one of very few urban landscapes that I have painted. I seldom include any buildings in my work, but this picture is an exception. The Black Rock Canal divides one of Buffalo's oldest commercial districts from the city's Squaw Island dump. Despite its seemingly hapless juxtaposition, the canal provides a refreshing oasis for both the eye and spirit. It's one of those tranquil pauses in the midst of industry, expressways, and debris that all too often goes unnoticed and unheralded. During my many years as a commuter, I took great pleasure in seeing the scullers glide quietly along the canal in a world apart from the surrounding urban frenzy. The separate serenity of a man in his boat in such an improbable milieu invoked a pleasant feeling that I sought to convey in paint.

Compositionally, the two land masses form opposing positive triangles. They are a study in contrast, with the clutter of sunlit buildings on the left balanced against the heavy solid bank of trees on the right. The eye is drawn to the center of the picture by the convergence of the two shapes, where it finds the single scull.

This is one of my earlier paintings and so it possesses a slightly tentative quality. In those days, I carefully thought about every dab of paint before I applied it and truly struggled my way through a painting. My work has since become more intuitive with cumulative experience; consequently, my application of paint has become less constrained.

DIVIDING THE LIGHT

I use light as my primary tool in constructing a composition. By seeking the big divisions of light and shade, I can establish designs that are simple and fresh as well as visually credible. It is very easy to be seduced by detail and lose sight of the larger transitions that can make the difference between a picture successfully "reading" or not. By emphasizing the major changes in light and giving minimal play to the more subtle nuances, a more powerful design has the opportunity to emerge.

Very often, my compositional ideas evolve simply from an object's shape. However, I can't always anticipate just how that shape will divide when it is placed in the light. Therefore, it is important to observe the subject carefully, often squinting, to separate it into its most basic components of light and shade, which can then be translated onto paper as simple shapes of color.

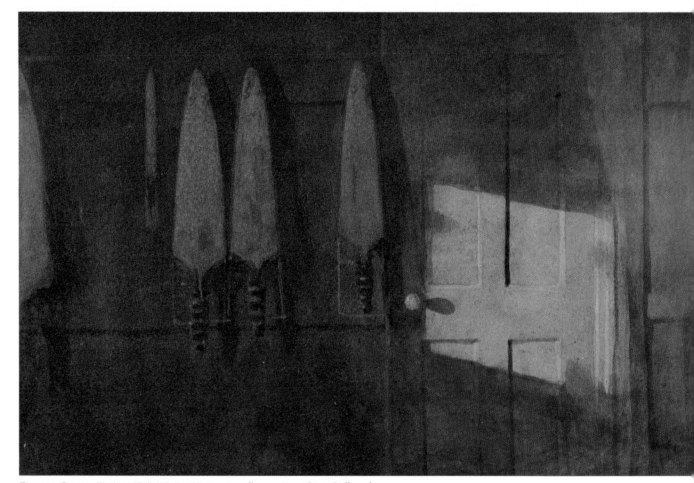

DRYING COON, 7⅜″ × 10⅞″ (18.7 × 27.6 cm), collection Daniel M. Galbreath.

DRYING COON

This picture relies upon a single patch of sunlight thrown onto a dark interior to create an extremely simple composition. The light forms a stark and interesting shape that is strategically placed in relation to the perimeter. Within the dark space the apparitional raccoon pelts add a certain element of mystery. However, the key ingredient is the spatial division achieved by a shape of light emitted from a pinpoint source.

WOODEN GULL

This picture is yet another solution to spatial division using light. Here, I have deliberately placed an object in the path of the light. A seagull decoy was propped up in the dark rafters of my barn so that it was partially illuminated. The resultant half-teardrop shape and its placement are the basis of the entire painting, illustrating how effectively one small division can work within a huge space.

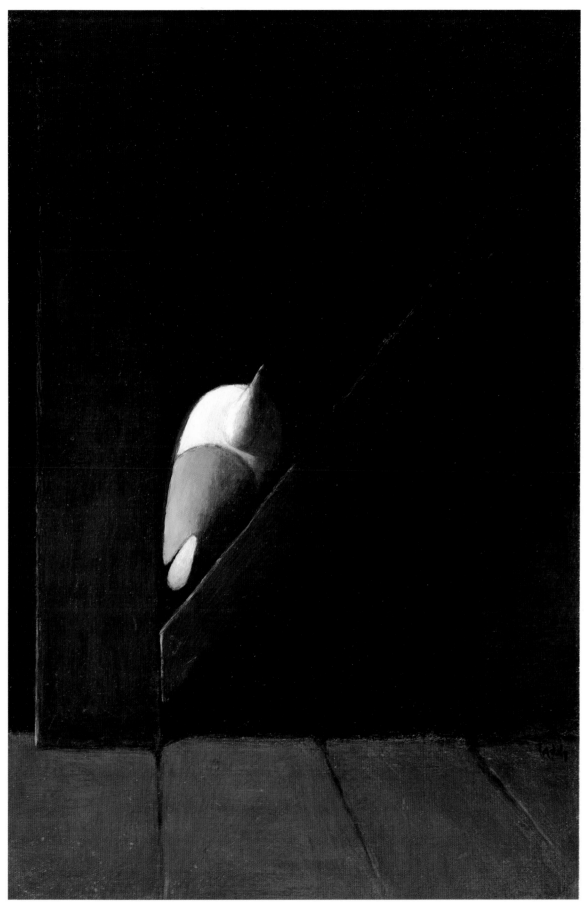

WOODEN GULL, *oil on board, 13¼″ × 9½″ (33.7 × 24.1 cm), collection Jeremyn Davern.*

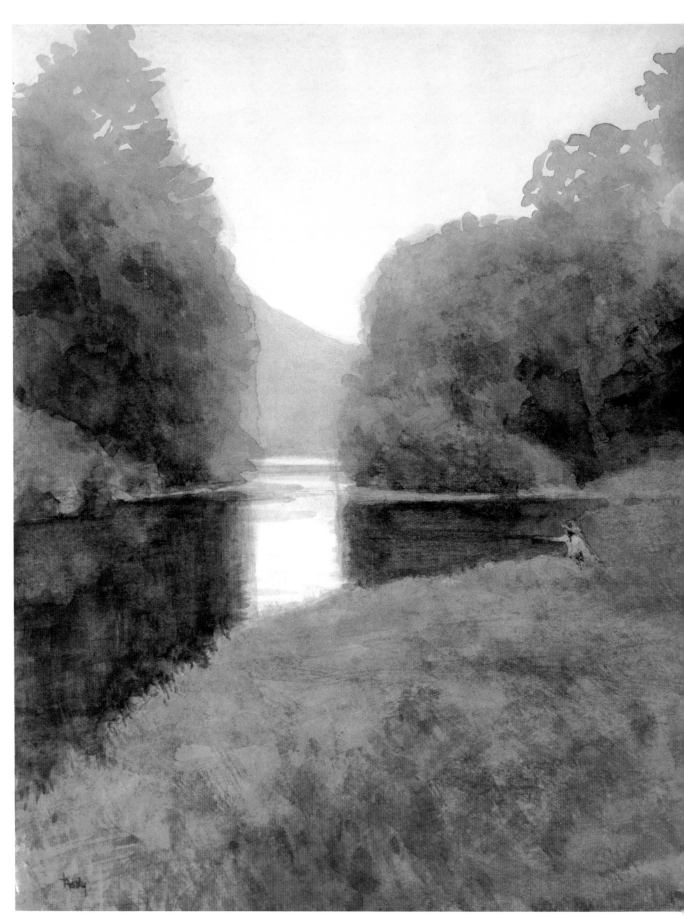

A Meadow by a Trout Stream, *11½″ × 9⅛″ (29.2 × 23.2 cm), collection Daniel M. Galbreath.*

A MEADOW BY A TROUT STREAM

Like many of my landscapes, this painting is reminiscent of the classic nineteenth-century idylls that were themselves created in response to the rapid industrialization of America. With the rapid pace of urban life and all of its ramifications, there seems to be a pervasive undercurrent of nostalgia for a more simple and serene existence. My personal expression of that common yearning lends many of my landscapes an innate appeal.

The idea that was the seed of this painting was to portray the silvery light of a bright overcast day against the landscape's resultant cool greens. I chose a large "T" shape for the light value and relegated the rest of the picture to the dark positive mass. This is an excellent example of the use of big spatial divisions, reducing the whole picture to essentially two values. While some gradations do appear within each value, they readily dissolve at a distance. The small figure seated on the bank was strategically placed as a negative dot within the large positive mass. It serves as a device for compositional balance as well as lending the landscape some scale.

The trees are dark at their bases and lighten as they roll outward and upward toward the sky. In retrospect, I feel that they could have been darker overall, because as upright forms, they really should be more than one value darker than the horizontal meadow.

The detail above shows the portion of this painting that I most enjoyed working on: the foreground grass. Here, I applied the paint freely but stopped well short of flashy splattering. I tried to use the broadest stroke that would still be perceived texturally as grass, implementing it with light and dark washes to create irregularities. While the meadow is warm in the foreground, it cools as it recedes into space, gradually becoming veiled by atmosphere.

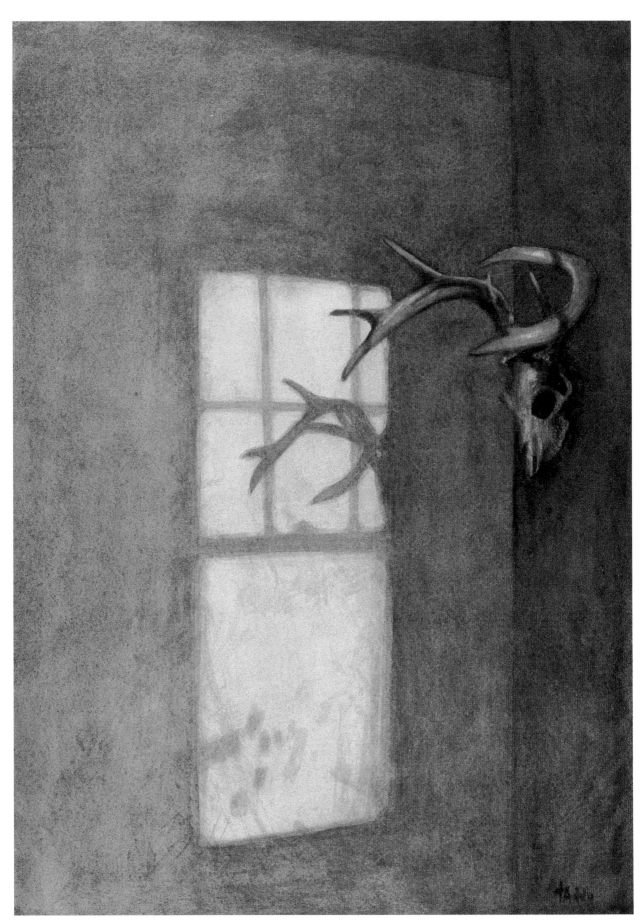

ANTLER SHADOWS, *12⅜″ × 8¾″ (31.4 × 22.2 cm), courtesy Grand Central Art Galleries, New York.*

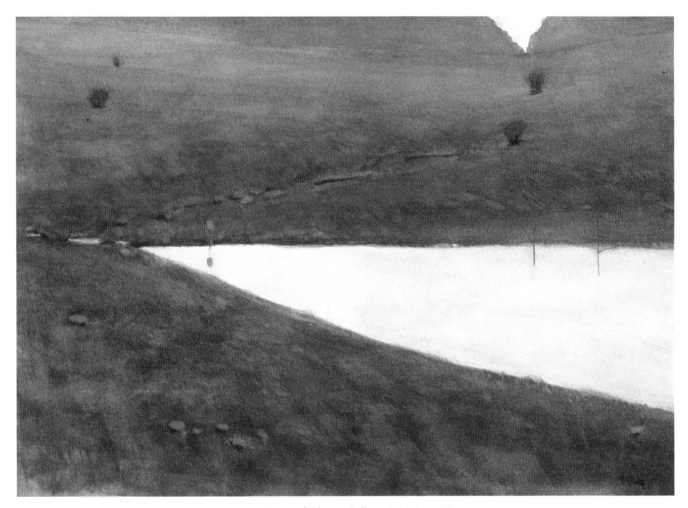

POND INLET, *8½″ × 12⅜″ (21.6 × 31.4 cm), courtesy Keny and Johnson Gallery, Columbus, Ohio.*

ANTLER SHADOWS

One evening the setting sun splashed this image across a wall in my home, and I immediately knew that I had the material for a dynamic picture. In arranging the composition, I edited out all of the extraneous furnishings so that its impact would not be diluted.

POND INLET

In this painting the major division occurs between the land mass and the reflected light of the sky. The sun has set, so the horizontal plane of field is no longer illuminated. However, the sky is still bright, and its mirrored reflection in the water is the essential element of this basically two-value composition.

THE PAINTING PROCESS

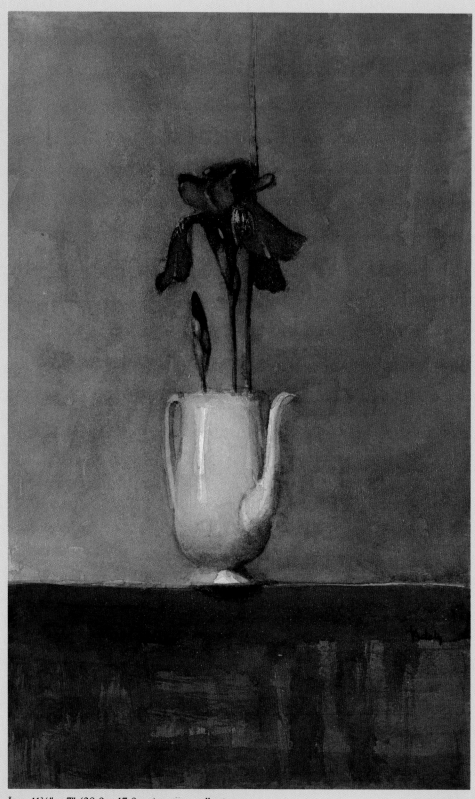

IRIS, 11⅜" × 7" (28.9 × 17.8 cm), *private collection.*

PAINT QUALITY

My greatest satisfaction as a painter comes during those moments when I am truly painting, that is, after my composition is arranged and the basic picture is conceived. My purest creative energy comes to fruition in the puddles, flecks, and patches of paint on the paper's surface rather than in what they represent. The internal dynamics of watercolor as a medium and the rich, sensual surfaces that can be created with it are the very qualities that keep me enthused about my work. Undoubtedly this emphasis on the very texture of paint is an outgrowth of my training during the peak years of abstract expressionism, when the reality of the picture plane was paramount. I enjoy allowing the watercolor to assert itself, creating a unifying textural quality among the elements of a strong classic design.

Watercolor is a medium capable of producing a depth and resonance that elude many painters. By literally working into the paper, scrubbing, sanding, and building layer upon translucent layer, a richness and patina can evolve that I find infinitely more interesting than the single-application techniques. While the final application of pigment may be completed in seconds, the preparation of the surface to receive it and ultimately enrich it is usually a time-consuming endeavor.

I recently saw a few of my small paintings enlarged into posters and was delighted with the resultant dematerialization of objects into wonderful, fragmented pools of color. The physical properties of the paint were so much more prominent at that scale that they totally overshadowed all of the pictures' other elements. And that is, in essence, the way I feel about my art. The primary enjoyment for me as a painter is the statement of paint on the paper surface.

MATERIALS

Because my work is generally small in format, I have considerable flexibility in my work space. Rather than use an easel, I am free to work anywhere with my painting in my lap. I use Arches 140-pound, hot press paper exclusively. I prefer the smooth, hard surface of this paper because it allows *me* to control the paint's texture. Painting can be a difficult enough task without the paper contributing its own unexpected humps and bumps. The few times that I have deviated from this paper, I have heartily regretted the decision; therefore, I make a practice of stockpiling a good supply.

To prepare a support on which to paint, I place a piece of Arches paper cut into a rectangle or a square on a Masonite board that measures 14″ × 18″. Then I take 2″ masking tape and tape it dry to the Masonite, approximately ¼″ or so from the edge of the paper. When the painting is finished and I strip the tape off the board, a clean, white border of paper remains and frames the completed painting.

I depend on three basic sable brushes, all with round ferrules; they are Winsor & Newton's nos. 3, 5, and 16. I also use Winsor & Newton tubed watercolors exclusively. I squeeze them out along the perimeter of a white porcelain meat tray and allow them to dry there, adding more only as they are used up. The center of the tray is used for mixing my colors as they are needed. My general watercolor palette consists of: cadmium red deep, cadmium orange, cadmium yellow, burnt sienna, warm sepia, alizarin crimson, Payne's gray, French ultramarine, Prussian blue, ivory black, Davy's gray (opaque), light red (opaque), olive green (opaque), cerulean blue (opaque).

WORKING SKETCHES

I very seldom use any preliminary sketches anymore, although I have found them to be quite useful in the past. Not only did I jot down myriads of reference sketches when I was outdoors, but I often recorded ideas as they occurred, regardless of where I might have been. This was particularly true when I was tied to the constraints of a "regular" job that kept me away from my studio for long periods of time. I would stockpile ideas that I could put to use at a later time when I would be free to paint.

Now, I occasionally roughly suggest the big areas of a design with a few swishes of paint. Also, when I am unsure of the exact placement of a particular shape or where to place the boundaries of a composition, I attempt to solve the problem through the use of very simple, very rough thumbnail sketches, such as those shown on this page and adjoining various paintings shown throughout the book.

STILL-LIFE DEMONSTRATION

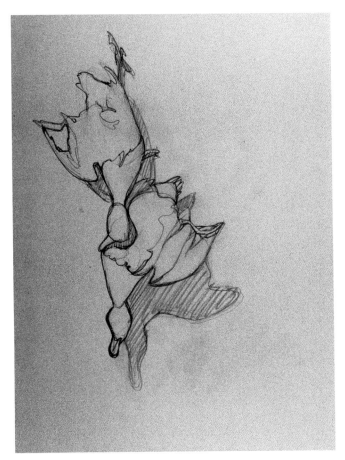

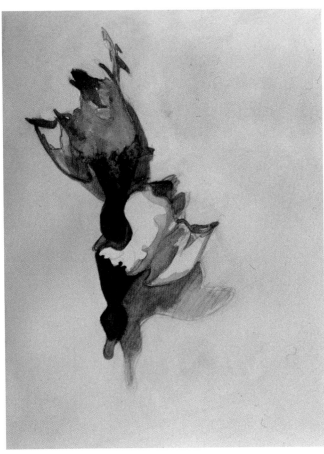

PENCIL DRAWING

This painting began with a carefully controlled pencil, drawing made directly on the watercolor paper. Although it is by no means a "finished" drawing, it clearly defines the areas to be blocked in with my initial washes. Before the paint is ever applied, most of my major decisions have already been made, as the drawing suggests. From now on, I hopefully need only concern myself with the application of pigment.

INITIAL PAINT APPLICATION—VALUES

My initial application of paint has served to approximate the value range that I have predetermined. Squinting my eyes, I massed the big dark areas together. At this stage almost all of my attention is directed toward the dark values, while the light areas receive only a faint tint to be built upon later. Here a very pale wash of burnt sienna and cadmium orange has been applied to the background wall to suggest its warmth. The dark warm areas are a mixture of cadmium orange and black, while the densest blacks consist of black beefed up with a touch of alizarin crimson to infuse it with a warm depth. Everything is quite hard-edged and will be softened later with the addition of halftones.

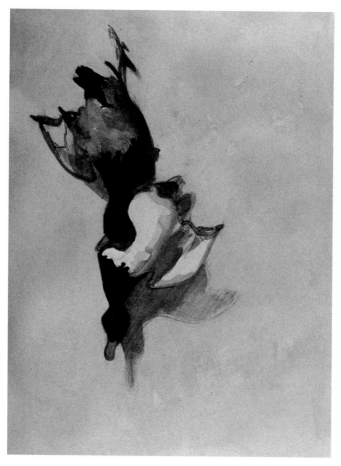

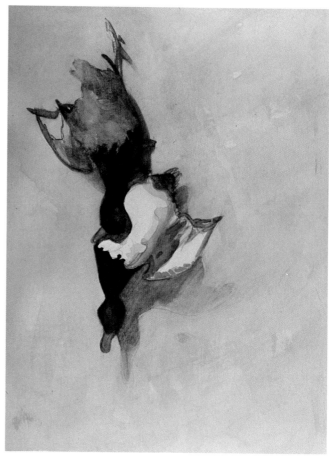

BACKGROUND WASHES

Another layer of washes has been applied to bring up the color and texture of the background wall. More definition has developed in the gray area, and the edges have started to soften. Most of the gray here is a mixture of cadmium orange and ultramarine. I create my grays by mixing complementary colors or near approximations. Each combination (for example, red/green vs. blue/orange) obviously has its own distinctive quality of gray. As the washes are layered from the paper up, each is applied with thought toward the future tints that will veil it.

REWORKING

Occasionally I choose to modify my drawing after a painting is well along, which, of course, mandates the removal of the existing paint in the area destined for change. In that case, I'll use either a fine sandpaper or a water-filled brush to scrub away the paint, then redraw and work the area back up with paint until it catches up to the rest of the picture. Here, dissatisfied with the drawing of the upper duck's tail, I scrubbed it out and left it to dry for a while before reworking. Meanwhile, the background wall has taken on a light tint of ultramarine to cool it back. As the light travels through the painting from the upper left to the lower right, the wall will need to lighten and cool. As raw tints are added to the background, there will be a play back and forth between warm and cool until in the final stages the ultramarine is more concentrated in the lower right. This constant layering will eventually yield a rich and interesting patina in the negative space rather than a dead flat wall.

ERASING PENCIL LINES (*right*)

Enough definition has developed in the painting to erase the remaining vestiges of the original pencil drawing. Considerably more depth and modeling have gone into the birds, and I have begun to rework the errant tail on the upper duck. The areas in shadow have begun to noticeably warm by contrast to the cool lit areas.

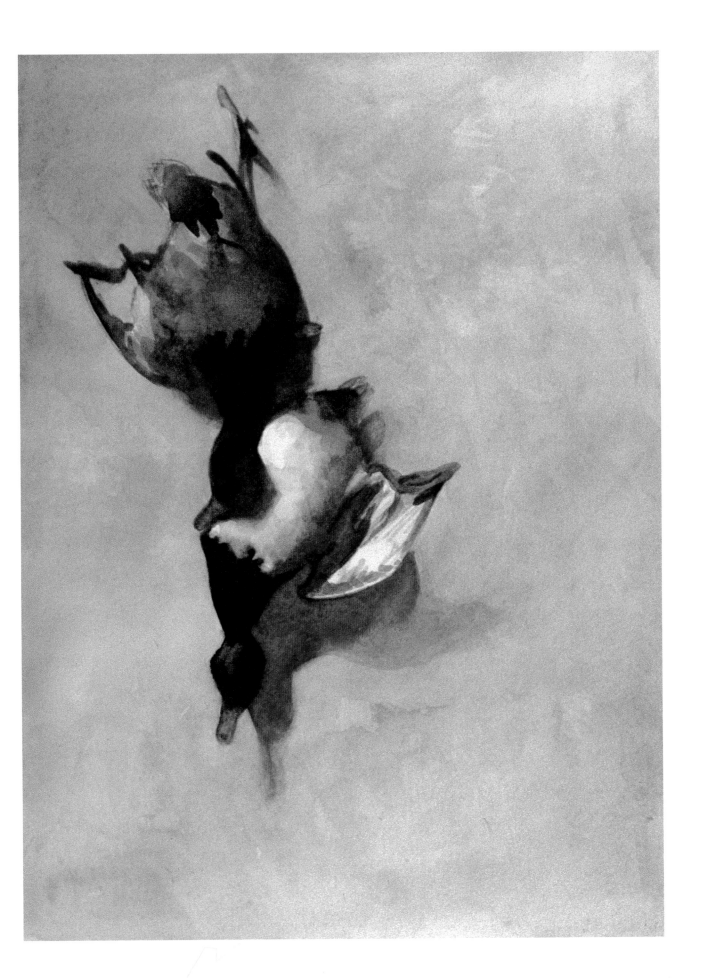

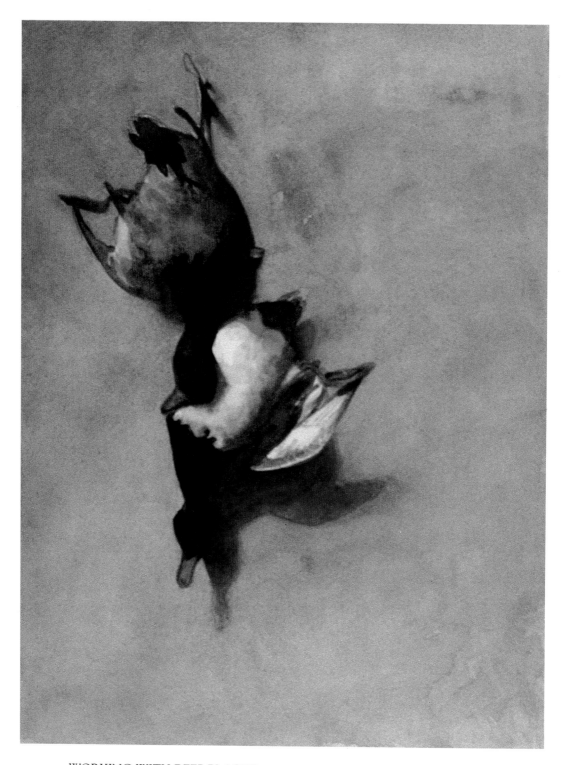

WORKING WITH DEEP BLACKS

The upper duck's tail has finally caught up with the rest of the painting. It presents the same problem as the other deep blacks in the picture, in that the local color of the birds' feathers dictates that these areas possess the darkest values, despite their position in full light. Because the black feathers do not reflect light, they remain deep and dark with no apparent modeling as they make the transition from light to shade. This is a phenomenon that seems to elude many painters. I have also added some more warmth to the cast shadows on the wall; a layering of burnt sienna, cadmium red, and black has been used to make the area dark and rich while maintaining a certain degree of luminosity.

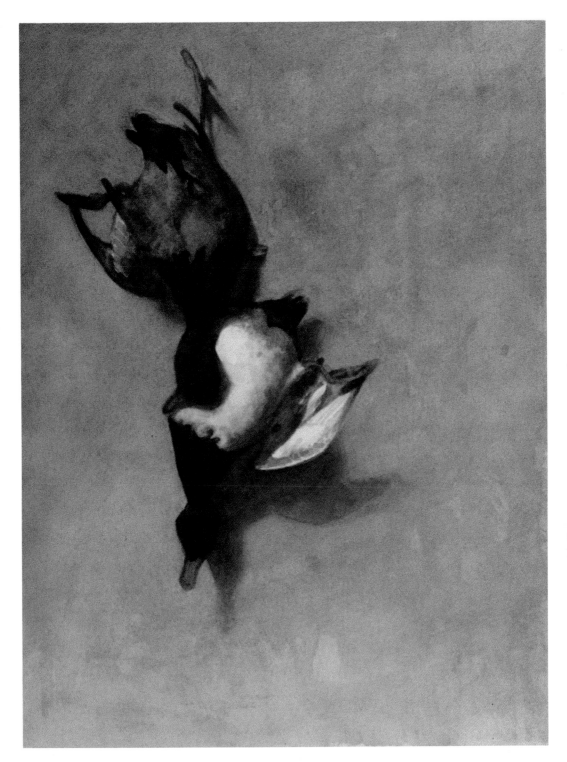

REFINING COLOR AND DETAIL

From my initial broad applications of paint, more refinement has developed
through the sequential layering of tints. While remaining true to the original
shapes that were outlined in my drawing, more detail and interest have evolved
within those areas. For example, I have picked up some accents in the cast
shadow on the lower duck's wings, thereby creating the illusion of being able to
see right into the shadow.

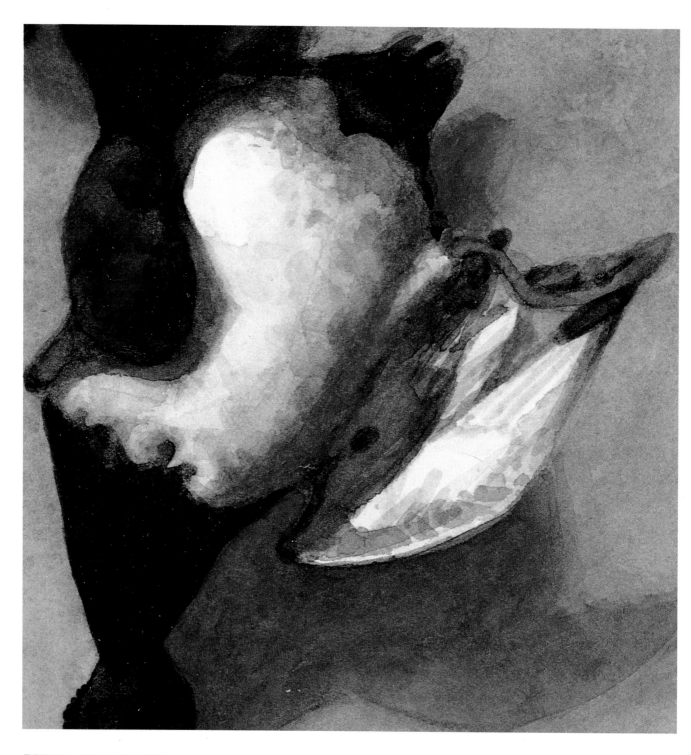

DETAIL—EDGE PLANES

Again, more subtle refinement has brought the painting close to completion. The values have been deepened and the color and surface quality have been enriched considerably. I've attended to the edge planes, endowing the ducks with viable form. For instance, the strongest light in the picture is on the lower duck's breast, which is oval in shape. The plane of the breast that turns toward the light source and away from the viewer has been rendered almost imperceptibly darker and cooler by the addition of a faint wash of ultramarine.

FINISHED PAINTING

I have painted many pictures of pairs of hanging ducks. However, I am particularly satisfied with the arrangement here, where the upper duck's head is placed against the white breast of the lower duck. I liked this composition so much that I am using a similar arrangement in an oil painting, although I'm deepening the tones in the oil for the effect of a later daylight. The compositional possibilities are as infinite with the array of shapes created by a pair of birds as are the options for lighting them—which is precisely why I consider game birds to be such a wealthy source of design.

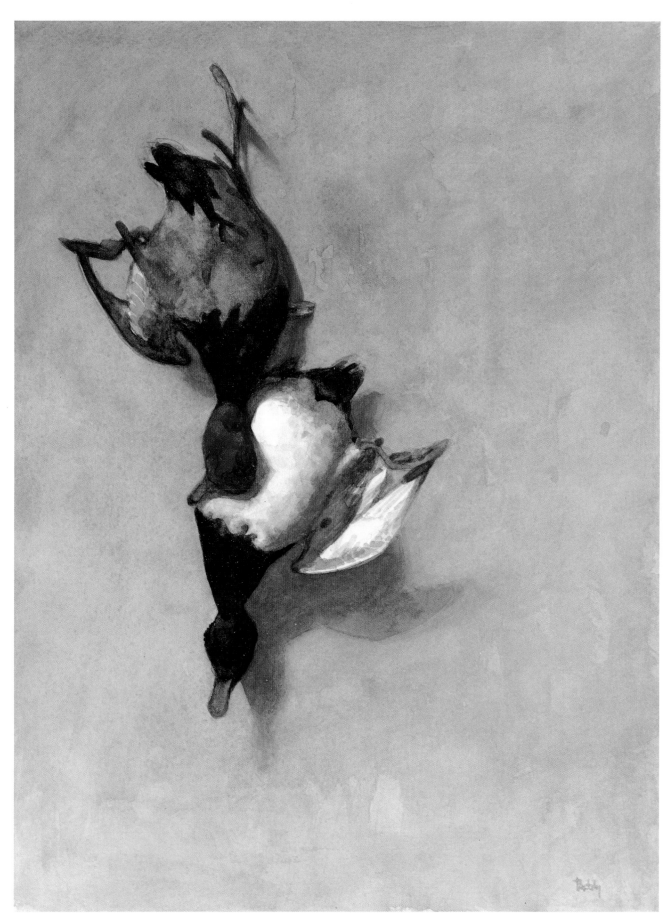

BLACK AND RED, *11⅝″ × 8¾″ (29.5 × 22.2 cm), courtesy Keny and Johnson Gallery, Columbus, Ohio.*

LANDSCAPE DEMONSTRATION

ROUGH SKETCH

The initial drawing is roughly suggested on the watercolor paper. The preliminary pencil drawings for my landscapes generally lack the precision and control of those I make for my still lifes. This is probably due to the looser forms that the masses of landscapes can assume, as opposed to the more exacting dimensions of still-life subjects. The only portion of a landscape drawing that I dwell upon is the figure—if one is present—as is the case here.

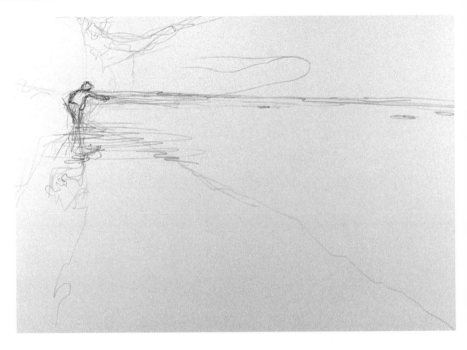

FIRST WASHES—ESTABLISHING VALUES

The large masses and their basic values have been approximated by the first washes. I used a mixture of Prussian blue, cadmium yellow, and cadmium red throughout to simply create a neutral gray/green base. While rough and monochromatic, the value relationships established here are enough to strongly foreshadow the final image.

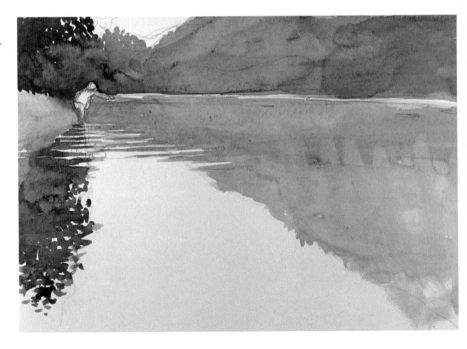

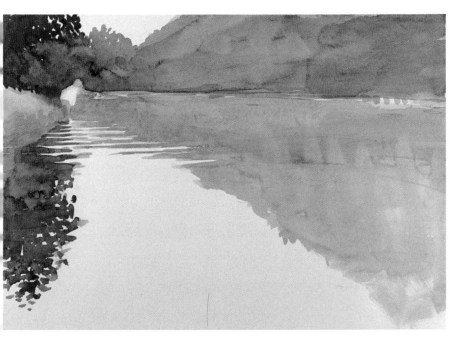

ERASING PENCIL LINES (*left*)

The pencil lines have been erased as they have served their purpose in guiding the initial wash application. I like to erase the graphite as soon as I possibly can so that it will not interfere with the paint. With the washes now defining the picture, I will have to proceed a bit carefully in and around the figure so as not to disturb the edges defined by my original drawing.

SUGGESTING SURFACE DETAIL (*below*)

I've begun to build up some surface variations within the large masses to suggest foliage and individual trees. At this stage the internal contrasts in value are a bit exaggerated, as I have just roughly blotched in paint. I have applied some ultramarine to cool the juncture of the far bank and the water, and I have deepened and cooled the dark tree on the left. In essence, what I've done is to set the interchange between warm and cool in motion.

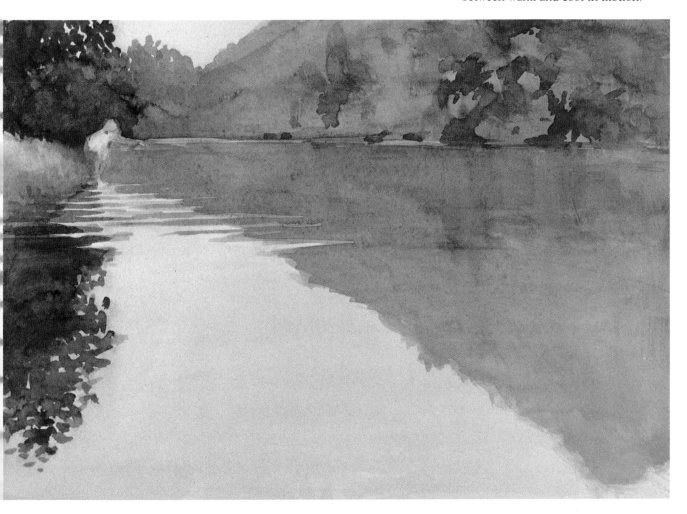

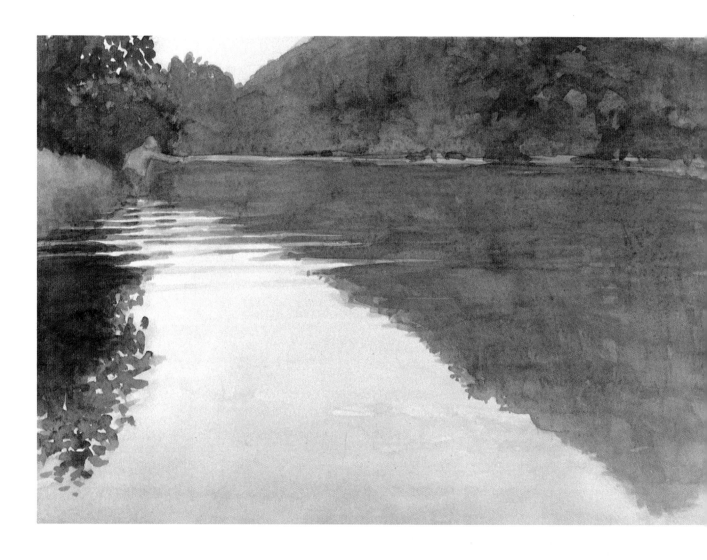

HANDLING REFLECTION

The reflection of the land has begun to cool off. Generally, a green mass such as this will lighten and cool when it is reflected in water. (If the water is muddy, the reflection is definitely lighter, whereas if the water is clear, the reflection will usually be darker.) The land's reflection in water also loses some definition and appears hazier than the land mass, even in dead still water.

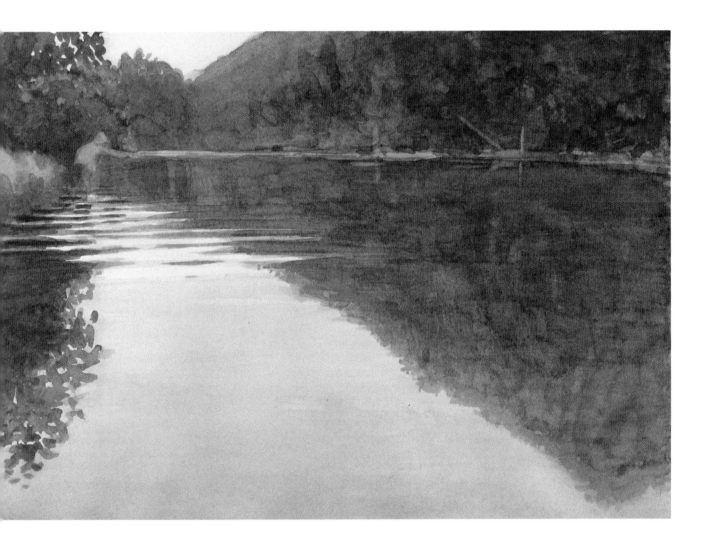

CREATING SUBTLE CHANGES IN LARGE MASSES

More concise definition has developed within the land mass
with the emergence of trees, dead timber, and bushes. Pure
washes of blue, red, and yellow have been applied as the
picture matures from its original neutral tones through a
continuous exchange between warm and cool.

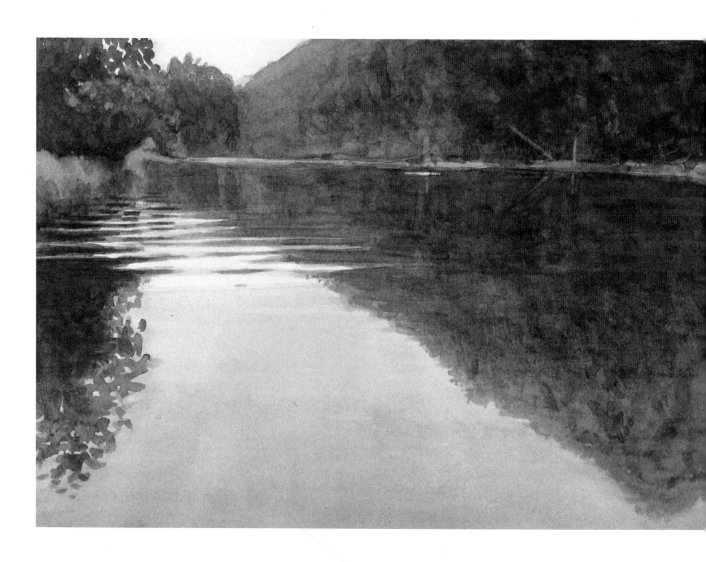

LIFTING OUT PIGMENT

With an X-Acto knife, I've scraped out a small white area depicting the ring of a rising trout. Since this was an integral part of the picture's concept from its inception, I chose to scratch out the pigment at this stage rather than paint around such a small area with countless washes. The lower portion of the reflection is finally starting to assume its relative warmth and light. The unseen top of the right hillside is the only area receiving a late day's sunlight, and its reflection serves to provide that information.

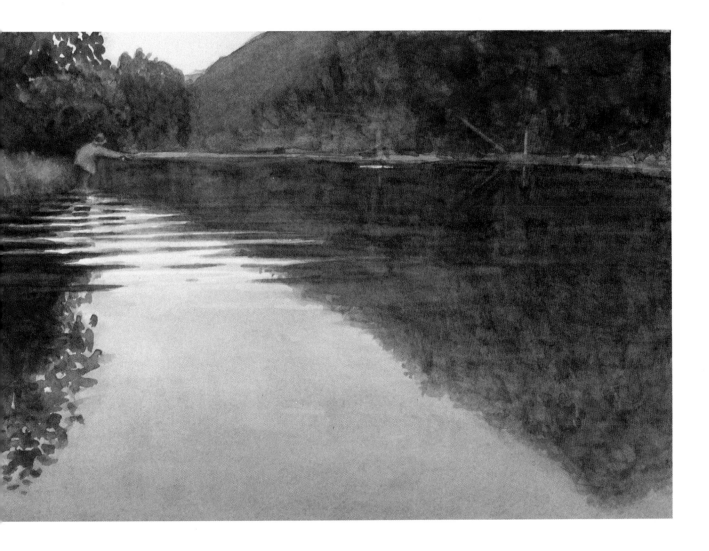

ENHANCING DARK VALUES

Near completion, there has been a final assault on the dark
values, adding accents to the deep recesses, thereby
punctuating the picture with its darkest darks. Once I feel
that my initial intent has been fulfilled, I'll set the painting
aside for several days and proceed with something else. Still
taped to the board, the painting will be scrutinized daily and
I may add small refinements in drawing and color, as well as
adjust relationships with an increased objectivity. At this
stage in *Far Trout* I was careful to refine the drawing in the
figure and then pull out the figure with paint.

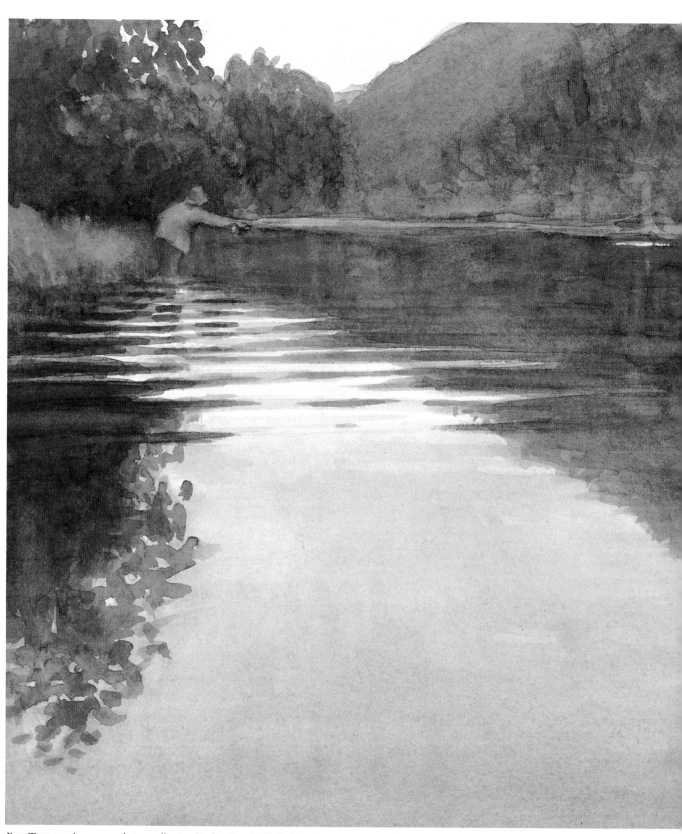

FAR TROUT, *shown actual size, collection Sterling Regal (H. Tashjian).*

FINISHED PAINTING

Finally satisfied that I have carried the picture as far as it should go, it is stripped from the board and signed. My original design concept was to use simple, large triangular shapes to cut the picture plane in half diagonally, which I feel I have accomplished here. I also think that I've captured the initial feeling that I strove for. The sensitive image of still water gently nudged into slow ripples as the fisherman casts his fly is one of the many subtle perceptual charms of trout fishing.

SAME SUBJECT, DIFFERENT MEDIA

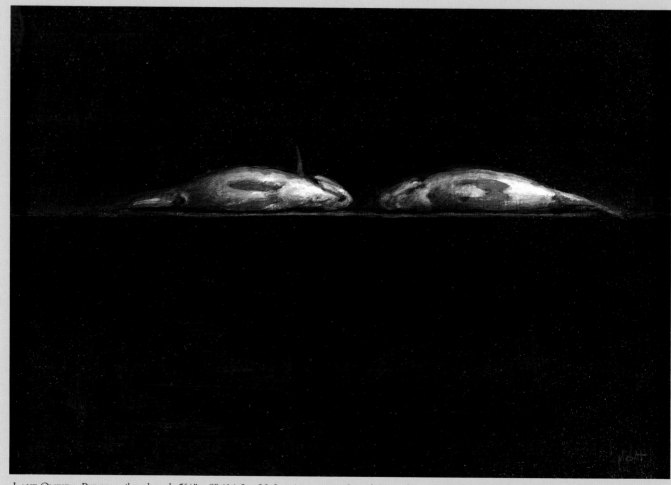

LAKE ONEIDA PERCH, *oil on board,* 5⅝″ × 8″ *(14.3 × 20.3 cm), courtesy Grand Central Art Galleries, New York.*

ONEIDA LAKE PERCH

In this particular oil painting, as in a handful of others, I chose to repaint a picture that I had previously done in watercolors. The fundamental design concept was to punctuate the dark negative field with two strategically placed teardrop shapes created by the undersides of a pair of perch. The watercolor version did not realize the full range of contrast that I had envisioned, yet I was very pleased with the picture as a whole. However, I felt that the watercolor definitely merited another attempt, so it was metamorphosed into an oil. The resultant color is deeper and stronger than in the original watercolor, and the rounded forms of the fish bellies are more delicately developed.

I will occasionally become discontented with the limitations of watercolors and resolve to convert an idea into oil paint. Whether it is the nature of the medium or my own ineptitude with the craft, I cannot achieve with watercolor the deep, rich tones that some of my still-life ideas demand. Oils not only provide the strong darks that I seek, but they additionally allow me a greater control when I wish to create a more subtle and delicate modeling of form.

On the following two pages, identical subject matter was executed in three different media. The watercolor entitled *Drum* turned out to be an exceptionally gratifying painting, and it subsequently inspired an unprecedented pair of sequel pieces. The arrangement of two adjoined fish created a lovely, simple shape, and the plump, shiny forms were a delight to paint.

When I first began to experiment with etching, I sought the security of working with a tried and true image, so *Drum* was translated into a black and white linear format for that purpose. I was still enthusiastic about the image after the edition was complete, and I couldn't resist the impulse to carry it to its logical conclusion as an oil painting. Thus, *Lake Erie Drum* evolved from the two preceding works.

This threesome clearly illustrates how the same composition can be varied by changing the medium selected for its expression. Each interpretation is unique, its distinguishing characteristics dictated by the physical properties of the materials employed.

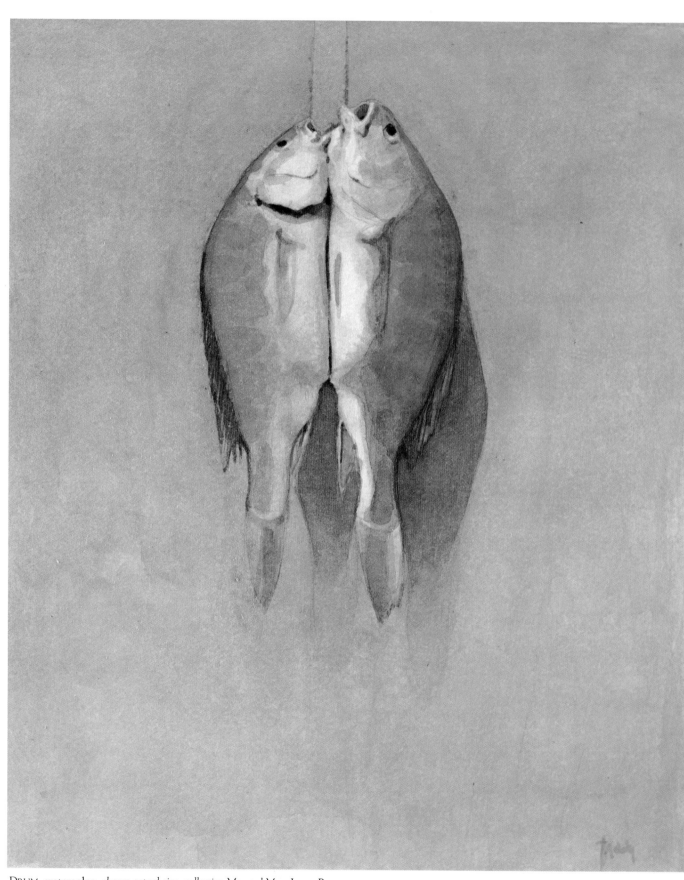

DRUM, watercolor, *shown actual size, collection Mr. and Mrs. James Roy.*

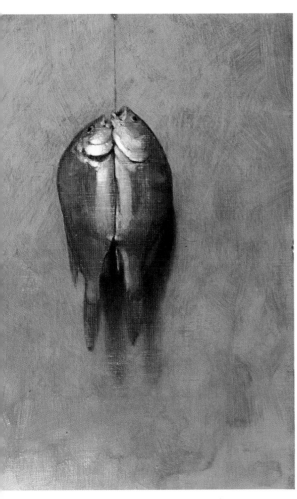

LAKE ERIE DRUM, *oil on board (unfinished), 11⅝″ × 8″ (29.5 × 20.3 cm), courtesy Thomas Aquinas Daly.*

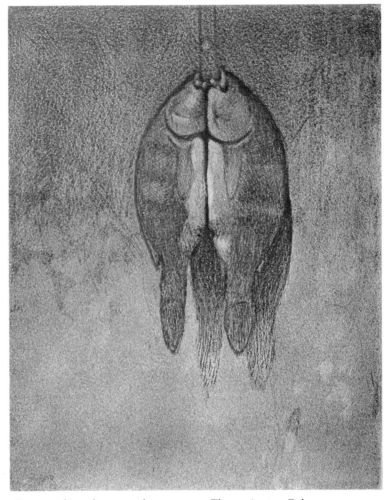

DRUM, *etching, shown actual size, courtesy Thomas Aquinas Daly.*

MODELING AND TEXTURES

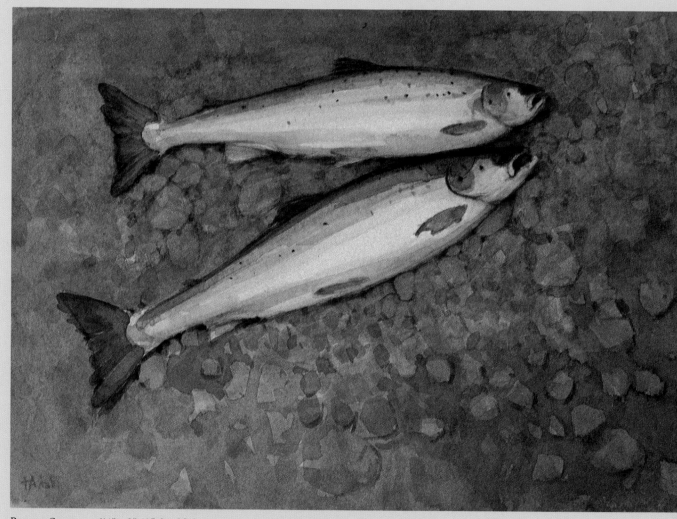

BRIGHT SALMON, 6¼″ × 9″ (15.9 × 22.9 cm), courtesy Grand Central Art Galleries, New York.

When people ask me how I go about defining the varied textures of my still-life material, I have a tendency to wince. I am immediately reminded of the legion of aspiring painters who are in search of a flashy trick or technique to help them circumvent the inevitable and arduous route to facility: *work*. There are no shortcuts to quality or easy solutions to painting. Snappy gimmicks yield shallow and insipid art.

Obviously, then, I don't adhere to any clever formula to portray porcelain as opposed to fur or feathers. Rather than waste time worrying about what my subject is made of, I'd rather channel my energy into really *seeing* what it looks like and translating that into paint. If I handle the task correctly, the tactile illusion will follow as a natural consequence. In my early years as a painter, I did indeed consider such things as "painting fur" a problem. I used to use a multitude of fastidious brushstrokes and attempt to recreate every hair. In retrospect, I realize how ludicrous my efforts were, for by submerging myself in minutiae, I lost sight of the image as a whole. As my aesthetic mind and eye matured, I learned that seeing the shapes of individual pieces of color and simply transferring them onto paper was really the key to painting anything successfully. You must develop the ability to recognize the big changes in a subject's color (its value, hue, and chroma) and take close account of how they separate visually. (For instance, you must note whether the changes are sharp or subtle, or if there is an edge plane turning away in the light.) Observe not only the shape of the color, but also the shape of its change.

The subject must be regarded in a purely abstract sense, completely devoid of an identity. Thus, instead of seeing a rabbit or a kettle, I have altered my thought process to envision an array of colored shapes delicately juxtaposed in almost a mosaic fashion. If successfully translated into paint, that vision will inherently depict the subject's texture simply as a by-product of good painting.

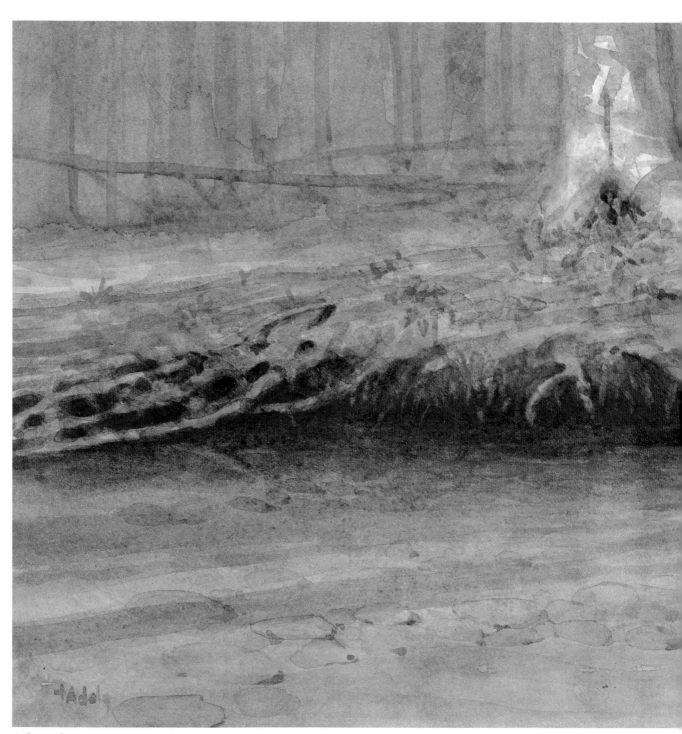

A Clear Pool in the Woods, *shown actual size, collection David Winterman.*

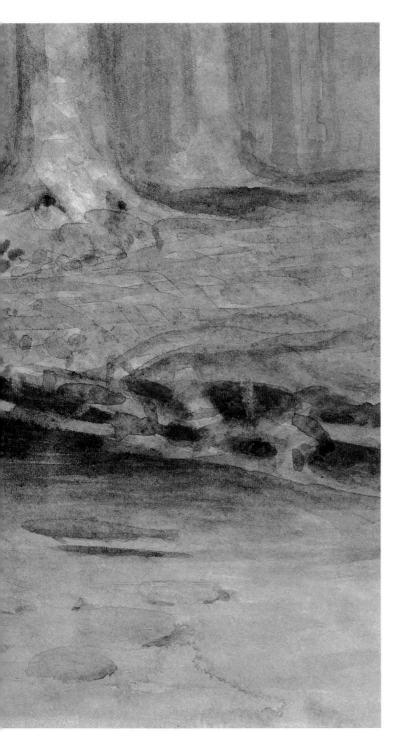

A CLEAR POOL IN THE WOODS

I became obsessed with trout fishing in my early teens, when I eagerly sought out small streams that slid through pastures and woods in order to fish for little brook trout. The trout often secrete themselves in places like that depicted in this painting, where the stream has undercut its bank. If extremely quiet, a person can occasionally steal upon a trout out in the open, unaware of human presence. The memory of the thrill and fascination of finding such a fish, relaxed and out of hiding, inspired me to paint this picture.

Even in a seemingly languid stream such as this, the water's persistent force has laid open the woodland floor, exposing its very bowels. The skeletal network of roots provided a key element in the picture's development. Their tangled diagonals break up the composition's dark horizontal bank into clusters of small, interesting shapes.

I was able to paint a fish suspended in the stream because I have carefully observed and analyzed fish in their environment for many years. I have found that the refraction of light in water gives a fish the illusion of being tipped toward the eye of the observer. Thus, I made the fish at a slight angle, rather than render it in profile.

I executed this piece with a slow and gradual buildup of washes. Because it was early spring, I wanted very light tones—soft greens and grays, and a little bit of light tan. The painting began as a raw sketch on white paper to which I applied a light, neutral mixture of cadmium orange and ultramarine blue. After letting the wash dry, I proceeded with successive layers, letting each dry before the next was applied. (The green washes were often created by combining Prussian blue with a warm color like cadmium yellow or cadmium orange.) As the painting neared completion, I gradually darkened the accents and shadows until the range of values read correctly.

I rarely premix my colors on the palette, because I prefer to let the overlap of washes manufacture optical mixtures as I work. I leave the paint free to take its own direction and I don't rigidly dictate the end result. This is not to say that the outcome is accidental, since experience has taught me what to expect. However, I find this a far more vital and stimulating way to paint than to be restricted to making one-application decisions.

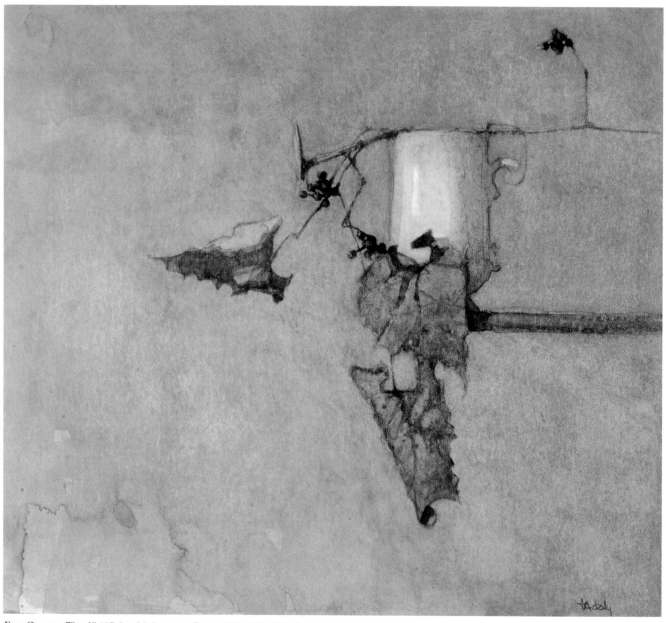

Fox Grape, 7" × 8" (17.8 × 20.3 cm), collection Mrs. John Warden.

FOX GRAPE

In autumn, the prolific fox grapes that drape over the trees furnish an abundant food source for wildlife. Their large leaves, delicate fruit, and graceful tendrils provide a visually interesting array of line and mass. As with all of my still-life paintings, I took a considerable amount of time to painstakingly arrange the subject in my studio before I commenced work.

This painting was a pioneer venture of a sort, as it was one of my first attempts to really control the medium with good solid modeling and drawing. Previously I lacked the confidence with watercolor to tackle this sort of a challenge. I have since learned that watercolor can be "pushed" and used to any extent you desire, and that it need not be treated as the intimidating, fragile endeavor that I had previously been led to believe.

When I reached an impasse in this piece, I resorted to rubbing the image down with sandpaper (a technique apparent in the leaf detail at right), and then building the surface up again. I have found that sanding works far more effectively than scrubbing the surface with water. In scrubbing, if the paper gets too wet, the sizing on the surface of the paper deteriorates, exposing the nap. This tends to fuzz the image, a paint quality that I avoid, as I prefer to maintain crisp, sharp definition.

I also use sandpaper for darkening tones, which can be seen in the close-up. By using a fine-grain sandpaper lightly over a dry area, you can deepen the dark values there by shining the surface. This is because an area of paint with a slight gloss appears to be more dense than a comparably painted area with a dull finish.

PAINTING WATER

There are an enormous number of variables at play when painting water. The imagery is so varied and diverse that it is virtually impossible for anyone to aspire to simplify it into neatly packaged formulas. All that I am capable of is fastidious observation and analysis of what is occurring physically to create the image before me. However, my overriding concern at all times is to regard it purely as an assemblage of shapes and colors.

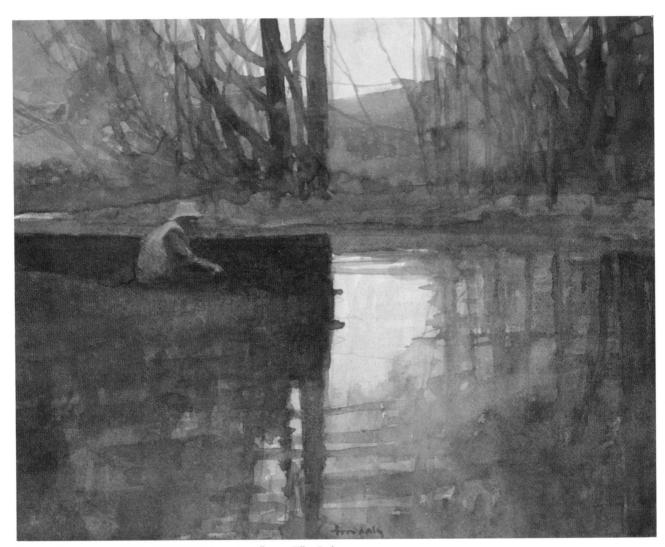

BRUCE'S BACKWATER, *5½″ × 7″ (14.0 × 17.8 cm), collection Elliot Liskin.*

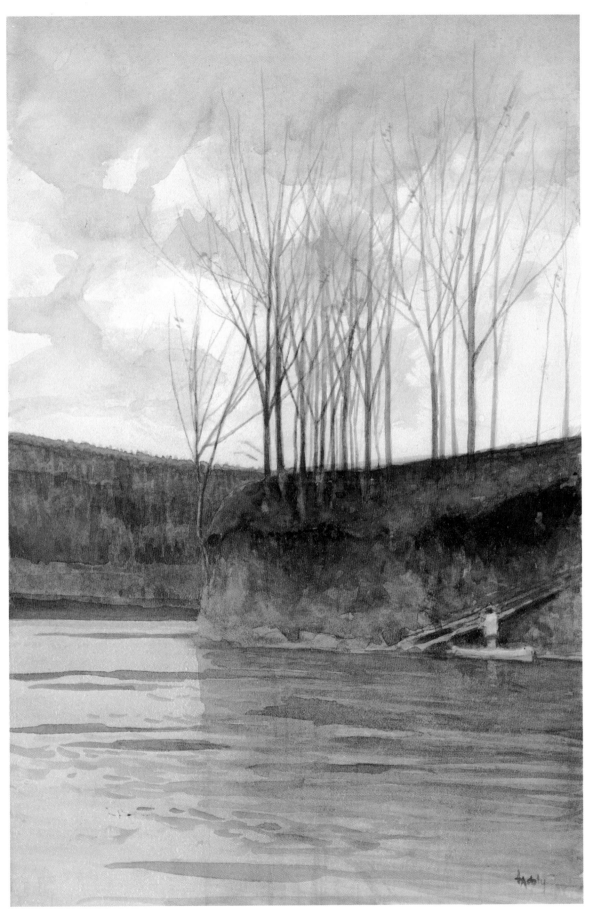

THE RIVER AT BLUESTONE, *11″ × 7⅜″ (27.9 × 18.7 cm), collection Robert Anderson.*

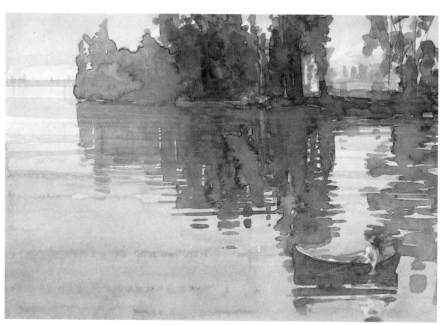

Canal Fisherman, 6⅝″ × 9¾″ (16.8 × 24.8 cm), *courtesy Stremmel Galleries Ltd., Reno, Nevada.*

"I learned that seeing the shapes of individual pieces of color and simply transferring them onto paper was really the key to painting anything successfully."

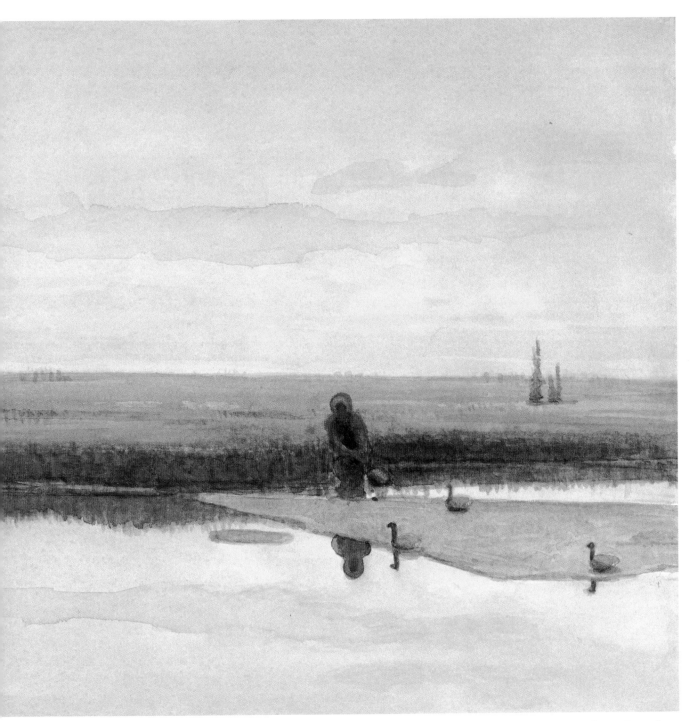

GOOSEHUNTER, *8¾″ × 12⅝″ (22.2 × 30.8 cm), collection James Cox.*

CHOOSING A SUBJECT

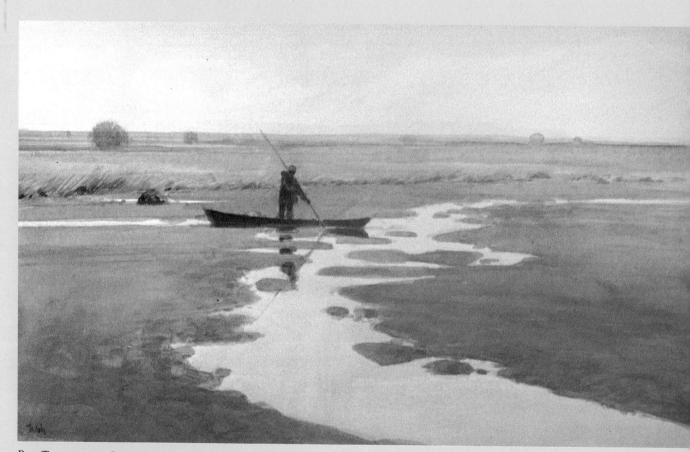

RAT TRAPPER AND SOME EARLY ICE, 7⅛″ × 11⅞″ (18.1 × 30.1 cm), courtesy Grand Central Art Galleries, New York.

In any representational painting, subject matter is of obvious import. While composition is my paramount concern, the arrangement of shapes and color in pure abstract design is a spiritless endeavor to me. I feel strongly about the exquisite beauty of nature's elements, and it is this passion that gives vitality to my work. The sensuous shapes and colors found in natural objects combined with the inherent challenges of light, air, space, and form present an infinite array of inspirational components upon which to draw.

I often use dead fish and game as subjects for my still-life paintings. But this generates some degree of controversy in that people occasionally claim to find them gruesome or morbid. This is quite contrary to my intent. I see in this dead wildlife an incredibly gorgeous arrangement of colors and shapes in wings, legs, beaks, plumage patterns, etc., which, unfortunately, can only become truly tangible when the animal is stopped, held, and scrutinized. These animals are intrinsically exquisite, and are even more so to me when they are carefully arranged in relation to other objects, negative space, and the perimeter of the picture.

The undeniable reality that man is the consummate predator disturbs many members of recent generations that grew up believing that meat spontaneously generates in cellophane wrappers on supermarket shelves. For preceding centuries, dead game was regarded as regular a part of kitchen fare as fruit or vegetables; and it was commonly depicted in still-life paintings as another life-sustaining element of nature's bounty. There are still those among us whose predatory instincts run close to the surface, and the satisfaction derived from such pursuits is as inexplicable as it is basal. While some people derive a primal gratification from digging in the earth or maintaining domesticated animals despite the fact that their survival no longer mandates it, others still feel compelled to reap the fauna that the land provides. The zenith of these predacious quests is the actual possession of the animal in hand, to hold, fondle, examine, and cherish a wild thing. It is this indefinable fascination with fish and game that compels me to use them in my painting, so that I might convey my own rapture over their incredible beauty.

It is a congruent sentiment that dictates the subject matter of my landscape paintings. The places that I paint are the spots that I frequent while hunting, fishing, and trapping. They are often the covers that hold game or the ponds and streams that teem with aquatic life. The scenes, apart from being visually appealing, are provocative to me, as they often raise a query regarding the animal life that may be concealed within. They are places that I have strong feeling for, and that feeling is what breathes life into my work.

I seldom include buildings or man-made structures in my paintings, probably because to me they lack profundity. Four walls and a roof can be readily understood, as they were contrived by another mortal. What fascinates and challenges me are the elusive qualities of trees, vast expanses of open fields, undercut banks, and how these

natural forms take light and transform from moment to moment. There is an enigmatic quality to water, with its infinite array of complexions; the turning of wave planes, the reflections of sky and land, and the shapes they create provide endless fodder for my work. I have an insatiable hunger to study, probe, and explore these subjects in an attempt to understand as much as I possibly can about the visual properties of my own environment.

Thus, my deep emotional involvement in my subject matter is the essential ingredient that carries my work. For years I floundered in a quandary over what to paint, until I realized the most rudimentary fact: that I should paint what moves me, and if handled with some degree of facility, it should in turn move others. The mistake that I feel a great many realists make is in laboring to render material that is totally devoid of feeling. While they can frequently display awesome technical mastery, in the final analysis the work is empty and expressionless. If a subject doesn't incite my emotions and possess my full sensory attention, it simply doesn't get painted. This is one of the reasons why I very seldom accept commissions. While I know that I can paint what is requested with a reasonable degree of competence, I also know that it runs the risk of being hollow. By selecting my subject matter with sentiment, I feel that I incorporate a spiritual dimension that is the essence and true strength of any vital art form.

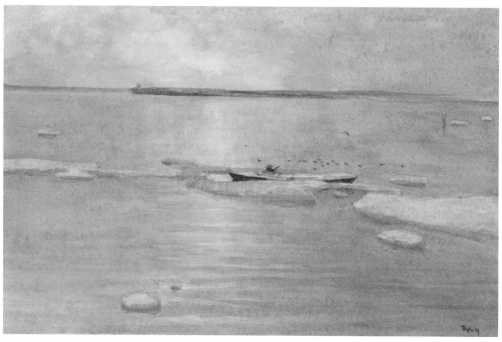

SHOOTING IN THE ICE FLOES, *8½″ × 12¼″ (21.6 × 31.8 cm), collection Kenneth Endick.*

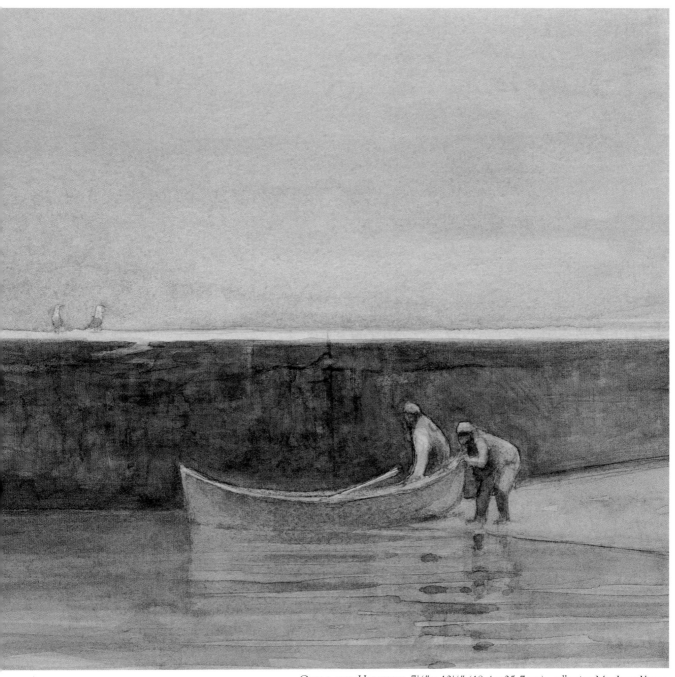

GULLS AND HUNTERS, *7¼″ × 10⅛″ (18.4 × 25.7 cm), collection Mr. Jerry Young.*

GULLS AND HUNTERS

In my paintings, I generally strive for understatement. Rather than paint the hackneyed and obvious scenarios of ducks flying under gun, I prefer to depict the quiet, reflective moments when a hunter is alone with his thoughts and environment. Gulls are constant companions at these times; thus I feel a special kinship with them.

The two gulls in this picture, resting atop the breakwall, reiterate the relationship of the two hunters. The sweeping shape of the boat leads the eye directly to the birds, whose bodies create a similar arc. I used the boat's beautiful curve to break up the heavy horizontal mass of the wall. Without it, the picture would have been too static. I feel that there are many answers to the same picture, and this painting simply happens to be one of various possible solutions that would have been equally workable.

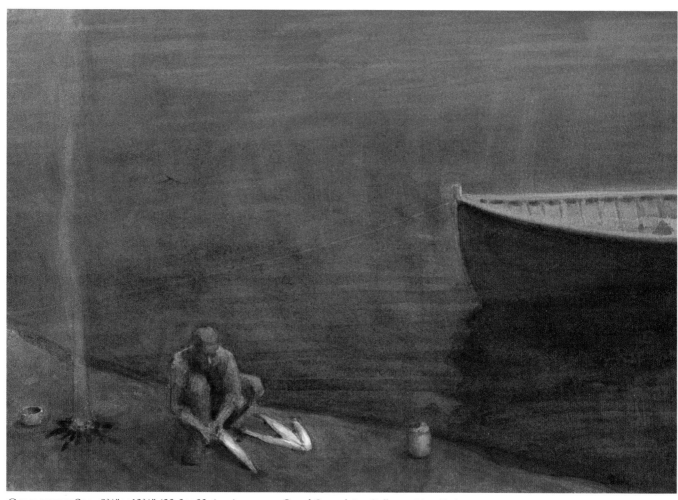

CAMP BY THE SEA, 8¾″ × 12¾″ (22.2 × 32.4 cm), courtesy Grand Central Art Galleries, New York.

CAMP BY THE SEA

This is a painting that I have a special affinity for, although I've discovered that it isn't as appealing to other people. It's a very personal piece, executed more with emotion than rational precision. My feeling was successfully conveyed, and that was my sole concern. In my opinion, my greatest expressions are conceived in this manner.

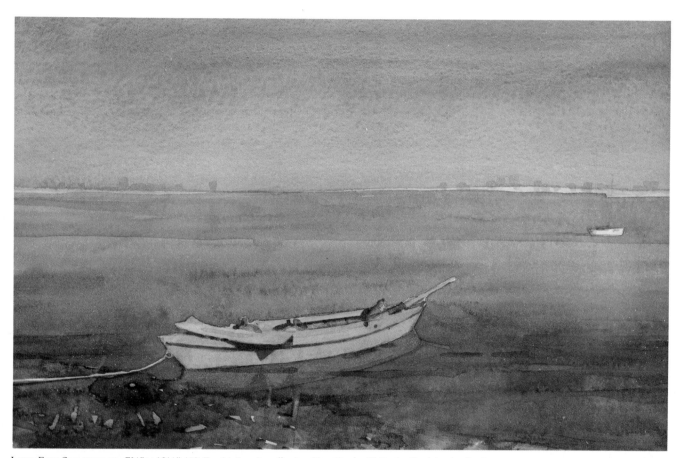

LAKE ERIE SNEAKBOAT, *7¾" × 12½" (19.7 × 31.8 cm), collection First Bank of Mandeville, Mandeville, Louisiana.*

LAKE ERIE SNEAK BOAT

This picture has a particular personal significance to me as it depicts one of my favorite subjects. The boat is my duck hunting skiff, my sole attempt at boat building. I find its slender crescent shape to be especially attractive, and I use it frequently when composing a picture. In this instance, I chose to isolate it within a large blue field, as I feel it to be a lovely enough shape to stand alone.

I built this boat for its aesthetic appeal as well as its function. Its design is uniquely adapted to a method of duck hunting known as sneak shooting. Because boats of this type are not readily available and I was eager to try this method of hunting, I built it myself in accordance with time-honored specifications. It turned out to be a most worthwhile endeavor, because not only is it a success as a hunting craft, it has inspired many a design.

SPRING TURKEY HUNTER

During the month of May the spring turkey hunters abound in the woods near my home. The standard method of hunting these wary birds is to lure the tom to the gun with a call that mimics the sound of a female. In this picture I have depicted a hunter patiently crouching beside a tree, playing his call to attract a gobbler.

The most extraordinary feature of this painting is the unprecedented way in which it was executed. The impressionistic flavor it possesses is quite a unique departure from my norm and, as a result, I truly enjoyed painting it. Instead of my more characteristic large shapes of divergent values, this is constituted of lightly dappled flecks of color within a fairly limited value range.

Spring Turkey Hunter was largely dictated by its subject matter. In early spring the woods are uniformly light in value, as the tiny new leaves allow a great deal of sunlight to penetrate and brighten the residual grays of winter and the emerging fresh, light green growth. The resultant homogeneous value made this a difficult picture to compose. I chose to emphasize the repetition of the light, vertical tree trunks as well as a few black stumps. The two vertical shafts of light on the central trees lead the eye directly to the crouching hunter. The patches of red, orange, and burnt sienna in the foreground and the remaining vestiges of the previous fall's leaf drop provide an interesting interplay of warmth against the predominantly pearly, cool landscape.

SPRING TURKEY HUNTER, *shown actual size, collection Jack Jeffrey.*

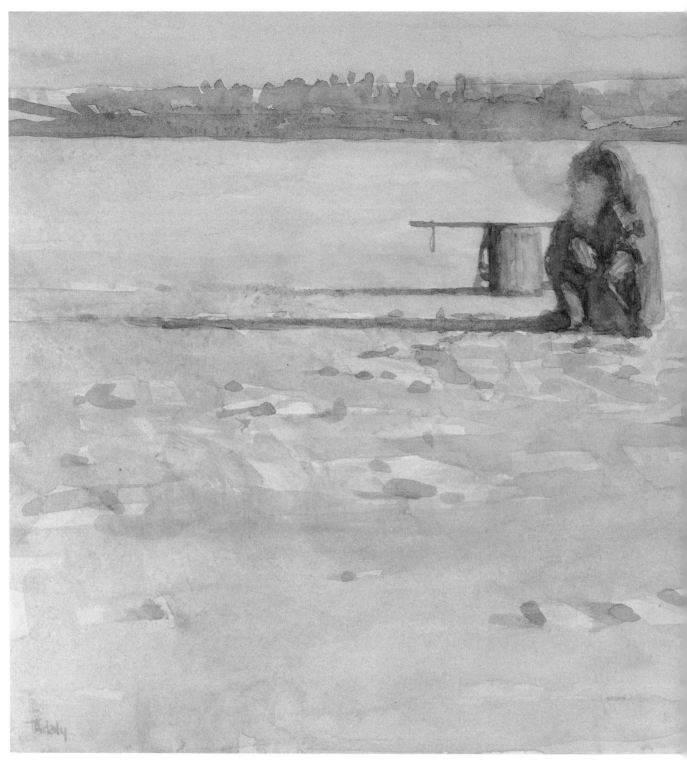

JIGGING FOR PERCH, *shown actual size, collection Anthony Depaul.*

JIGGING FOR PERCH

On late winter afternoons, the hunched figures of ice fishermen and the long shadows they cast atop the vast frozen lake are a familiar sight, and one that translated easily into a painting. This was the first of several such pictures and I consider it to be among my strongest.

Because of the huge expanse of negative space, I chose to connect all of the dark masses to form a single positive shape. The horizontal land mass is repeated in the long shadows and ice spud, while the form of the man and his packbasket are the only vertical elements.

One of the questions that I am most frequently asked is why I choose to include a figure in so many of my landscapes. One of the main reasons that comes to mind is that the figure adds an element of scale. I usually depict a solitary man, dwarfed by his natural surroundings and insignificant by comparison. In this particular painting, the figure has assumed a greater proportion than is the norm in my work; in fact, the lone fisherman on the barren ice has become the picture's focal point. However, he still appears to be precariously at the mercy of his host.

The figures in my landscapes generally share another common purpose. They are most often in the process of reaping sustenance from their environment. Whether they are hunters, fishermen, trappers, or gatherers, they are all people making use of the land and its bounty, people who have found the "right place" to fulfill their need.

The warm, yellow light in this painting is coming from the right and at an angle. The vertical chunks of snow and ice shown in the detail above stick up out of the smooth, horizontal blanket of snow, creating a broken surface in places. These cool, shaded spots are the result of light hitting one side of a projecting piece of snow, which leaves a hard, dark shadow on the other side where the light can't reach.

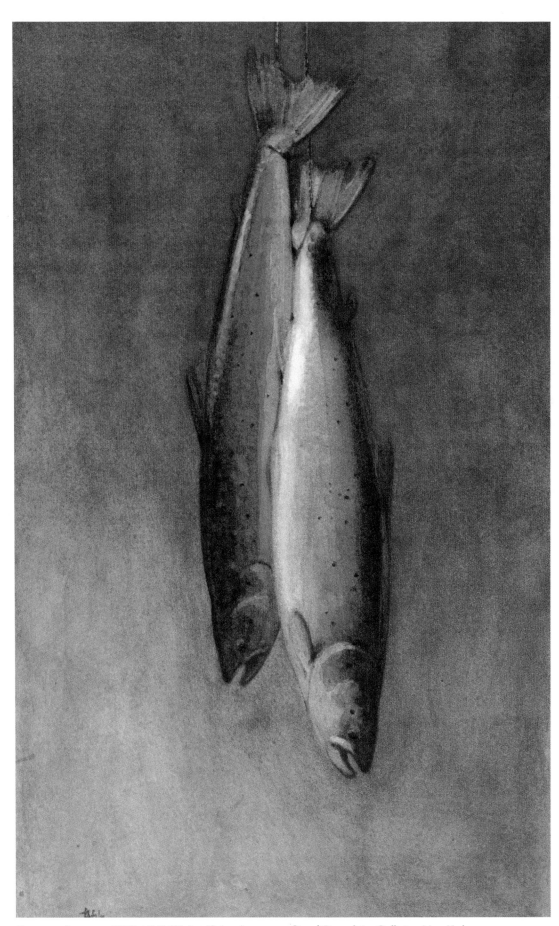

PORTAGE SALMON, *12¼″ × 7½″ (31.1 × 19.1 cm), courtesy Grand Central Art Galleries, New York.*

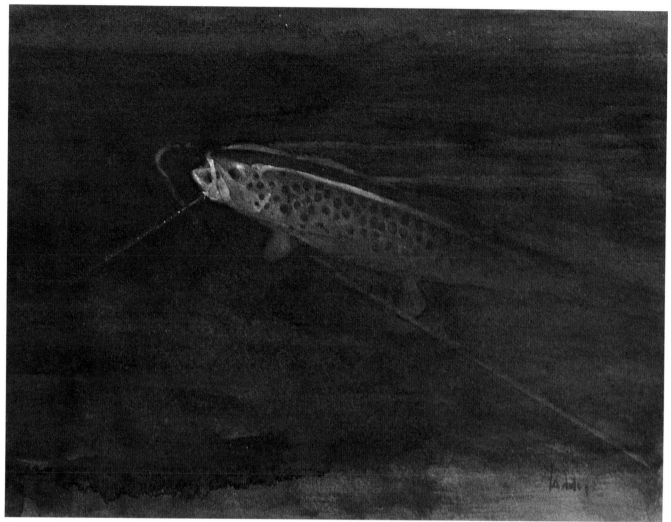

TROUT AND FLY, 5⅞" × 8" (14.9 × 20.3 cm), *courtesy Grand Central Art Galleries, New York.*

PORTAGE SALMON

In my opinion, the Atlantic salmon is the quintessential fish. Its shape is simple, subtle, and elegant—a total joy to paint.

TROUT AND FLY

This painting is a total departure from my customary portrayal of a fish. It was actually born of a whim that I had while trout fishing. I had my camera along so I shot a picture of a small trout lying in the water at the end of my line. The resulting slide was interesting and yielded the idea for this painting.

VARIETY IN SUBJECT TREATMENT

Since subject matter is merely a vehicle for the abstract elements of my painting, I never feel that the use of recurring images flirts with redundancy. By varying the composition and light (color), the same subject can appear in an infinite array of pictures.

Because I paint things that I am personally involved with, my range of material is naturally somewhat limited. As a result, some subjects may appear in several entirely different pictures. This is certainly not my attempt to achieve extra mileage from a tired idea. Quite to the contrary, a beautiful shape, such as the sneak boat that appears in *Marsh Hunter* and *Three Birds Coming to a Sneak Rig*, stimulates my enthusiasm, and a flurry of ideas often erupts as a result.

For instance, a frequent subject in my work is a man in a boat against a backdrop of sky and water. While the same man and the same boat may appear repeatedly, the composition, color, light, and feeling in each instance are significantly different, making each painting totally unique. I could easily continue to paint the subject indefinitely because its elements adapt so readily to my design. Thus, since a particular subject only serves to support the essential primary concept, the actual subject is relatively inconsequential in determining variety within the body of my work.

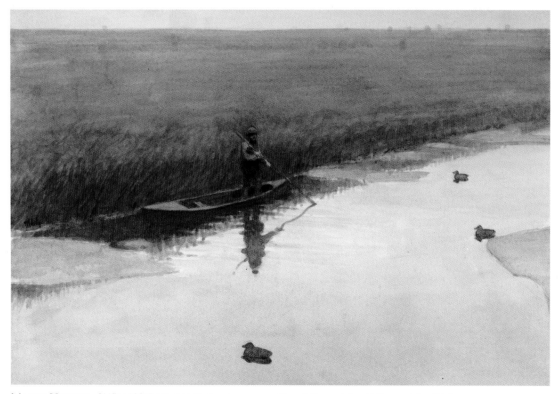

MARSH HUNTER, *8½" × 12⅝" (21.6 × 32.1 cm), courtesy Grand Central Art Galleries, New York.*

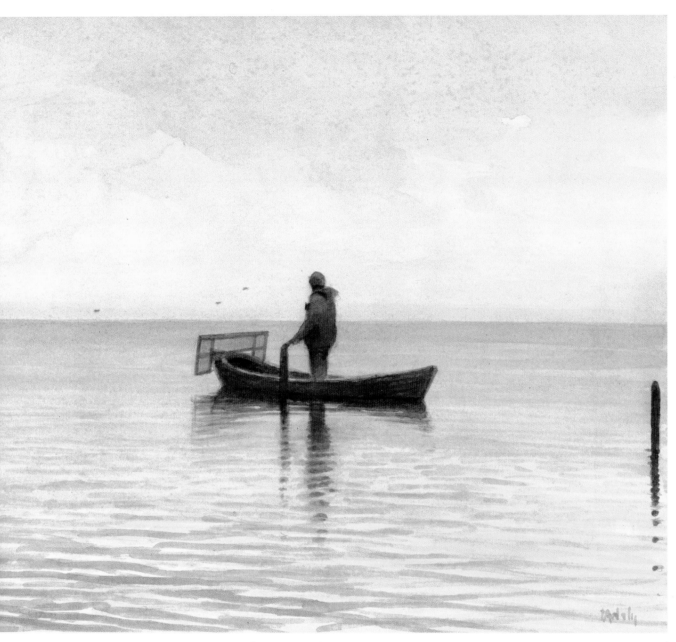

THREE BIRDS COMING TO A SNEAK RIG, *7⅜″ × 10¾″ (18.7 × 27.3 cm)*, *courtesy* Gray's Sporting Journal.

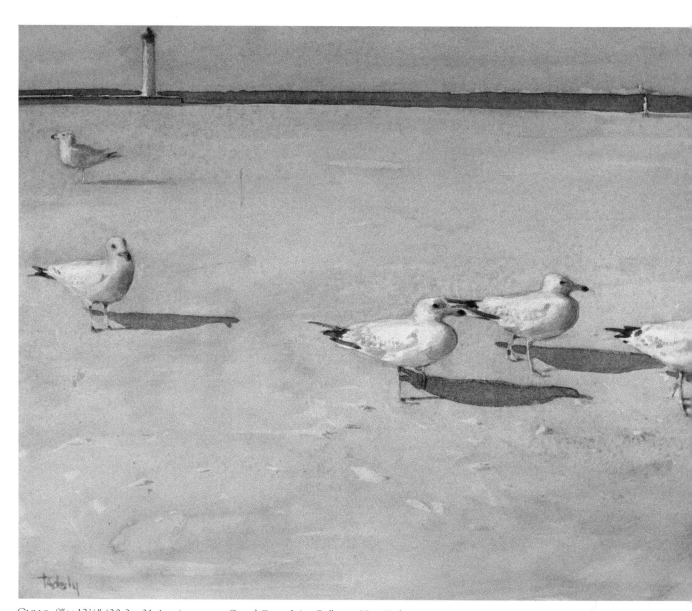

GULLS, 8″ × 12⅜″ (20.3 × 31.4 cm), courtesy Grand Central Art Galleries, New York.

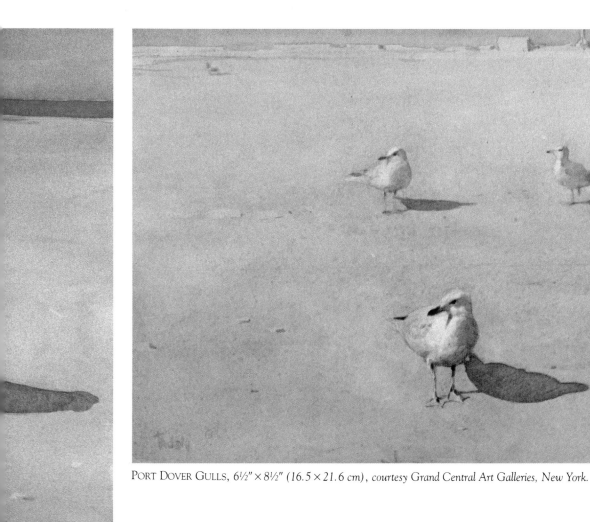

PORT DOVER GULLS, 6½″ × 8½″ (16.5 × 21.6 cm), courtesy Grand Central Art Galleries, New York.

GULLS

These two watercolors were painted back to back after I had taken time to watch some gulls in the strong light of an early autumn morning; and they are only two of an infinite sequence of arrangements that came to mind.

I have always been enamored with bird shapes, and gulls are one of the few species that permit close observation. The other birds that I paint are all much too elusive to scrutinize alive; consequently, they are used for still-life study. I will not take a dead specimen as reference and portray it as alive. I feel that it is only legitimate for me to paint things as I know them to be. The only living animals that I portray are pictured at a range where it is natural to view them. I won't pretend to describe them in a way in which they can't really be perceived by the naked eye. Thus, most of the animal life that I paint is either at a distance or dead. Gulls are a rare exception as their bold, gregarious nature allows a natural familiarity.

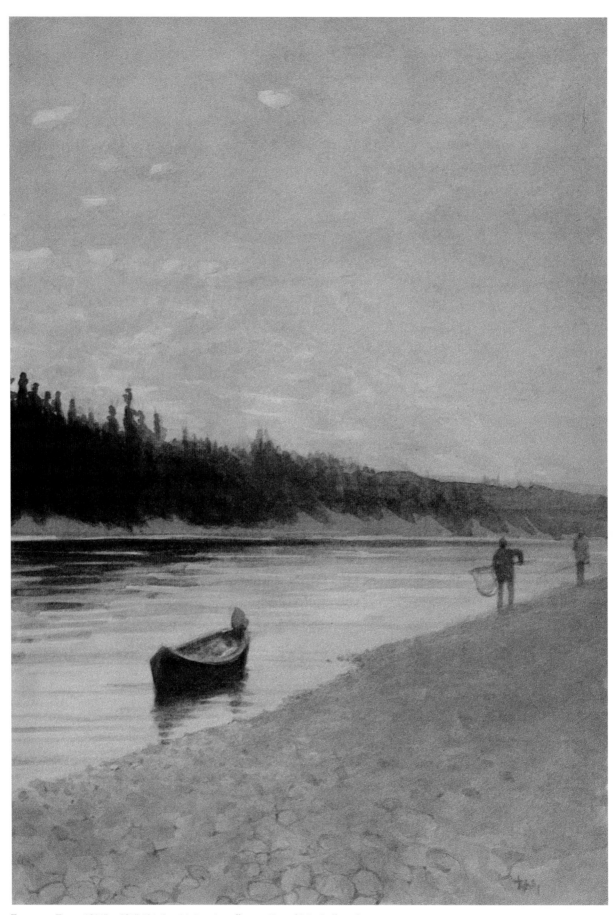

EVENING FISH, *12½″ × 8⅝″ (31.8 × 21.9 cm), collection Daniel M. Galbreath.*

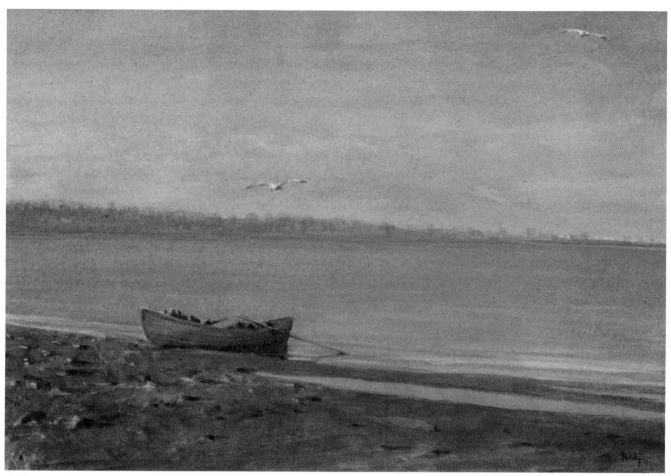

A HUNTER'S BOAT, *8″ × 12⅛″ (20.3 × 30.8 cm)*, *courtesy Gray's Sporting Journal.*

A HUNTER'S BOAT

Most sporting art dwells upon the fleeting moments of high drama in hunting and fishing. The focus is typically on the peak of the action, whether it's the flushing birds or the leaping fish. My preference is to describe the more subtle circumstances, such as the respite that spawned this painting.

PAINTING FROM MEMORY

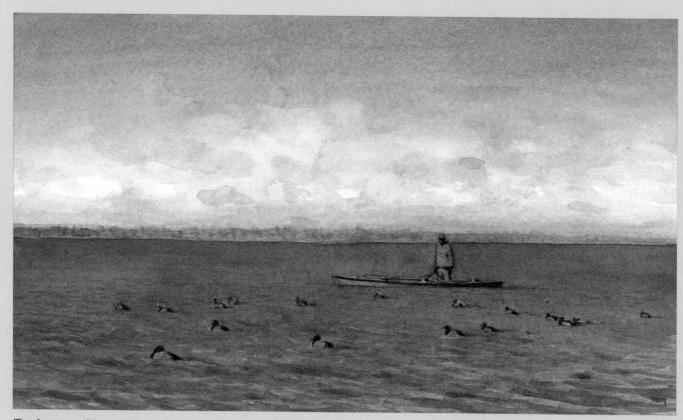

THE LIGHTING HOLE, *7⅞″ × 13½″ (20.0 × 34.3 cm), collection Jack Parker.*

Some of the best pictures that I have ever painted have been from memory. Perhaps this is because the extraneous detail is forgotten and only the undiluted essence is retained. The ideas that are implemented in my work are generally the by-products of other activities. I never venture outdoors in search of landscape imagery. Instead, I find myself besieged with ideas as a consequence of hunting, fishing, and trapping. Regardless of the nature of my primary activity, however, I am always seeing as a painter, perpetually translating the visual world around me into two-dimensional design. Because I am not constantly armed with a pencil, paint, or camera, I have come to depend on my memory rather than immediate sketching. When I am taken with a specific image, I'll sometimes pause and analyze its components and commit it to memory. However, it seldom translates literally. When I finally go about painting it, my memory is often more stirred by the pervasive feeling of a place than by its visual reality.

In order to successfully convert a nebulous array of feelings and mental imagery into a concrete two-dimensional design, there is no shortcut for experience. A painter needs to paint an enormous volume of work, and from practice will stem facility. After struggling through hundreds of paintings, a reserve of resource material accumulates in one's mind. Thus, when the need arises for a particular array of circumstances, you'll have the experience and knowledge at hand to tackle the problem without need of external reference.

In my early experience, I found the use of thumbnail sketches in the field to be an invaluable tool for study. I did hundreds of literal sketches of trees, light, planes, etc., directly from nature until I eventually developed the ability and confidence to work from memory.

My present work is no longer the verbatim rendering of a subject; instead it has been heavily infused with my own feelings and ideas. Knowing a bird, for instance, no longer means to me the authentic depiction of the correct number of primary feathers on its wing. Instead, it is knowing the bird multidimensionally—and consequently possessing an emotional response to it. The successful depiction of this feeling is the product of my evolution as a painter.

While you are still learning, it is very important to concentrate on being literal. A fledgling painter is a veritable clean slate and has to work at stockpiling skills. By struggling through innumerable problems and eventually finding solutions, you cumulatively develop a mental warehouse of causes and effects. This all serves as reference for subsequent painting, freeing you from the constraints of literal translations, allowing for a more personal expression while still remaining within the realm of representational art.

Painting from memory is an integral part of my still-life work as well as my landscapes. The subjects are often collected on my outings and are usually quite ephemeral in nature. Anyone who has ever caught a fish realizes how quickly they

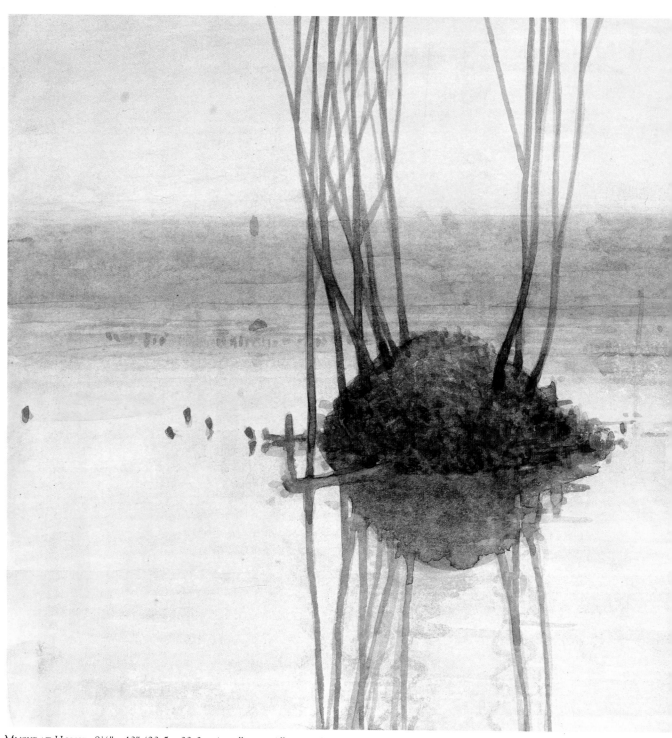

MUSKRAT HOUSE, *9¼″ × 13″ (23.5 × 33.0 cm), collection Allan Harsh.*

fade in spite of heroic efforts to preserve them. Rapidly wilting wildflowers present a problem as well. I will often draw them and make notations on their color that can trigger my memory and rekindle a feeling. I will sometimes use photographs for reference, but I find that they fail to record some of the more elusive sensory perceptions that can be retrieved from my mind.

When I return to my studio after being outdoors, I'm refreshed and eager to tap the flow of ideas that I've generated. I have found a successful balance between my work and my recreation, with each complementing the other. I sometimes become so enthusiastic about painting after an outing that I will squander my energy greedily, grabbing at all of my new ideas while the memories are still fresh. This is obviously counterproductive and certainly unnecessary, for I have successfully painted pictures from memories as old as twenty-five years.

MUSKRAT HOUSE

Muskrats usually choose to build their houses in shallow water and will often implement a small stand of trees as a framework. Not only do the trees provide additional strength for the structure, but they also help to camouflage the true identity of the thatched dwellings. In this picture, the muskrats inhabiting a beaver swamp have selected a flooded clump of alders as their scaffolding. While it appears to be a rather conspicuous island in the pond's expanse, in actuality it is only a few feet from the shore, which is the picture's vantage point. From any other angle, the muskrat house blends into the adjacent swampy brush.

In walking along the bank and discovering this solitary house, I immediately realized that I had been given a picture. The isolated mound and its tentaclelike trusses create a unique combination of line and mass and provide the elements of a novel design. Like my other landscapes, this is not an absolutely faithful portrait of a place. Painted only from memory, it is instead a graphic impression of what I saw and felt there. The hard factuality has been edited in order to facilitate that impression.

THE "L," *10″ × 7⅜″ (25.4 × 18.7 cm), collection Mary Lane.*

The "L" is unique in its conception, as it was more of a spiritual, self-indulgent homage to a special place than academic picture making.

The title of the painting refers to a bend in a small limestone creek that runs through the town of Mumford, New York. This creek is one of only two limestone streams in all of New York State. With its origins in an underground limestone deposit, it is rich in nutrients to support abundant plant and insect life. It is heavily laden with watercress in addition to trout throughout its brief four to five mile meander through the backyards and business district of town. Because of its unique, almost European-character and rich bounty, the "L" has drawn me hypnotically for over thirty years.

Today, the "L" is a "lost" place, as the town's efforts to tidy up its banks have uprooted the willows and shored up the banks with boulders, destroying the trouts' habitat. I painted it here as it used to be, when friends would gather on quiet spring evenings to fish for the trout that lay beneath the weeds in the shade of the willows. There was always a magical quality to this place, as the trout gently rose to feed on the hatches of bright fox in the twilight, and the gospel music of a nearby congregation drifted through the air.

Thus, this painting was conceived out of a reverent nostalgia. While it is a competent design, its primary attribute is an intangible essence, an airy vision of a serene and idyllic place that no longer exists.

Like *The "L" Mill Street* is a portrayal of a favorite place within the village of Caledonia, New York. A tiny brook divides two residential yards in the heart of town, and it is spanned by a large concrete archway that my friends and I have long known as "the tunnel." The shadowy water is a reliable source of trout, which, coupled with its intrinsic visual appeal, has made it a natural choice for subject matter.

MILL STREET, *11¾″ × 8″ (29.9 × 20.3 cm), courtesy Grand Central Art Galleries, New York.*

SALMON CAMP, *10½" × 7" (26.7 × 17.8 cm), collection* Sports Afield *magazine.*

SALMON CAMP

This picture is a scene from my first salmon fishing trip in Newfoundland. We set up camp on a south coast river that had a good run of grilse—the small young salmon on their first trip upstream. My very first salmon was hung near the cook fire just as it appears here, and my reminiscence of that wondrous silver fish was the basis for this painting.

Twilight with a Rising Moon, *13″ × 9″ (33.0 × 22.9 cm), courtesy Grand Central Art Galleries, New York.*

TWILIGHT WITH A RISING MOON

Painted from my memory without any source of reference, *Twilight with a Rising Moon* proved to be a bit of a problem. I had an idea for a towering cloud formation catching the very last sunlight of the day, while twilight enveloped a field below. It was a rather unique lighting problem that caused me some apprehension; however, in the end, I was satisfied with the result.

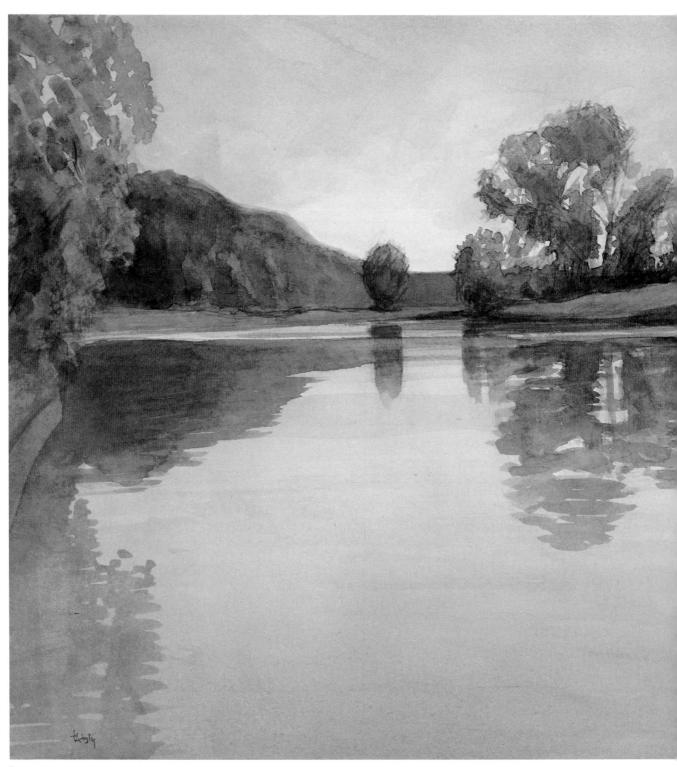

RIVER FISHING, 8¾" × 13¼" (22.2 × 33.7 cm), collection Daniel M. Galbreath.

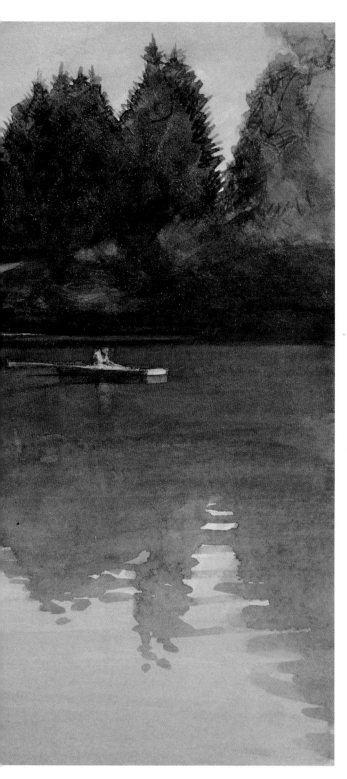

PAINTING A SPECIAL PLACE

Whenever I paint a place that is special to me, I hope that I can effectively reproduce the same sense of spiritual well-being in the viewer as I have experienced myself. Nature has a way of diverting us from ourselves, enabling us for a time to rise above our weakness and pettiness to be soothed and cleansed. One's ego can readily vanish in the face of a mightier force, resulting in a refreshing clarity and inner peace. One reassuring thread of consistency in our often schizoid lives is nature's adherence to its own quiet and eternal laws. Regardless of the unforseen jolts that life may offer up, summer will still follow spring, and so on. There is a great comfort in that kind of predictability. Perhaps such peace of soul is at the root of the calming effect that many people attribute to my landscapes.

RIVER FISHING

This landscape is in many ways reminiscent of the romantic pastorals of the last century. It is a product of my own physical and spiritual communion with a beautiful place near my home. The Genesee River is a vital and abundant source of many resources, ranging from fertile farmland to profuse wildlife to food for the eye, mind, and soul. It appears frequently in my work because it is such a special and habitual haunt of mine. As John Constable said, "I should paint my own places best . . . those scenes made me a painter."

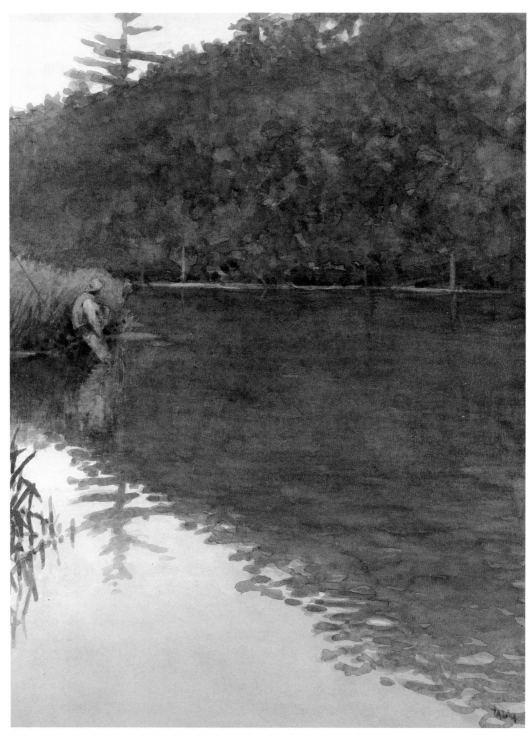

A PLACE ON THE WISCOY, *12¼″ × 9¼″ (31.1 × 23.5 cm), collection Mr. and Mrs. E. Saniga.*

A PLACE ON THE WISCOY

This picture depicts one of my favorite sanctuaries, a quiet stretch of Wiscoy Creek known as Mills' Mills. This charming place very near my home appears in several of my paintings because it possesses both emotional and physical appeal. The stream is accessible only from one side, as the other is composed of a steep shale cliff with a heavily wooded overhang. The slow water below holds large trout that are particularly elusive.

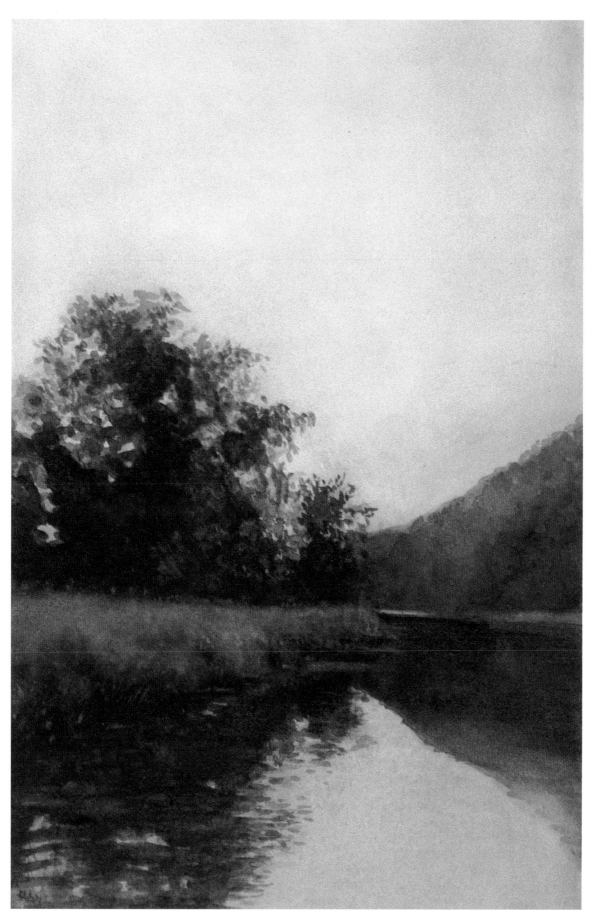

MILL'S MILLS WATER, *12⅞″ × 8⅜″ (32.7 × 21.3 cm), courtesy Keny and Johnson Gallery, Columbus, Ohio.*

PAINTING THE LIGHT

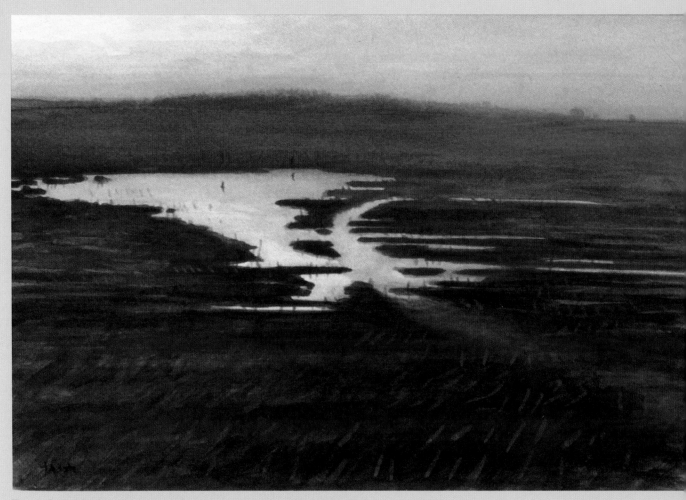

FLYING SNIPE, 8¾″ × 12¾″ (22.2 × 32.4 cm), courtesy Grand Central Art Galleries, New York.

To the realistic painter, a working knowledge of properties of light and atmosphere is of paramount importance. Because light itself is color and form, its significance cannot be overstated. Insight into its attributes is invaluable, and the rules that are studied early on can lay the groundwork for a more intuitive approach later on.

Indoor light generally has the advantage of being controllable. As long as the source is a north window, there can be no change in its direction, only variations in its color and intensity. The brightest light will occur on a lightly overcast day, and the darkest light will be on a clear day with a deep blue sky.

Generally speaking, the lit areas in a still life will be cool while the shadows (both cast and form) will be warm. The shadows will be affected by the size and color of the room, since reflecting light can change their appearance considerably. (For instance, a small white room will bounce far more light back into the shadows than will a large dark room.) An ideal learning situation would provide a direct and concentrated light source in a large room. Under these circumstances the distinction between light and shade would be readily apparent, and the observer would be best able to interpret the "two big parts" of the composition.

Personally, I make little effort to control the light in my studio. I have one small skylight that provides a concentrated source of light, and for the most part, I take what I get. When I run into a problem distinguishing what belongs to the light and what to the shade, I have found it helpful to view the arrangement in the dim light of the day's end. If the time is right, I will occasionally stop in midmeal and dash out to the studio in order to determine precisely where the separation between light and shade occurs.

In contrast to indoor light, *outdoor light* is infinite in its complexities, so I can only attempt to convey the rudiments and oversimplify them at best. As in any picture making, the key is to recognize the big divisions.

An *overcast day* offers diffused light from the entire sky; it literally rains light uniformly, thereby eliminating any real concern over its direction. The quality of the specific day's light as well as the time of day will determine its color, which should be carefully noted. In general, the lit areas will be cooler, while the shadows are warm and lack sharp definition. The upright planes will hold the darkest values while the horizontals will be lighter. With the notable exception of snow-covered ground, the sky should be the lightest of all values in the picture.

On a *sunny day*, midday offers several hours with little change in the quality and color of the light. While it lacks the drama of early or late light, it allows the artist a longer period of time to study the subject. Contrary to the overcast day, everything in sunlight will be warm and everything in shadow will be cool. One of the major exceptions to this rule can occur when there is a great deal of reflected warm light (as when the side of a yellow house warms its adjacent shadows). Otherwise, the only

light in most cast shadows is the reflection of the deep blue sky; consequently, the shadows are blue.

An important point to keep in mind when painting landscapes is that a lightly overcast sky emits a brighter light than a clear and sunny one. And because the sky is brighter on a gray day, the land masses appear darker than on a sunny day. This is so because the contrast that exists between the brightly lit overcast sky and the darker local color of the land mass is greater than on a sunny day, when the sky and ground are closer to the same value.

Toward evening, as the sun sets and shadows elongate, the evidence of the light's direction becomes sharply exaggerated. The upright planes, such as trees and walls, are cut in half with sunlight and are no longer necessarily the darkest values. At this time of day, the color of light and shade can present a real problem. There is a pervasive orange-yellow film overall, and it must be handled thoughtfully. While there is often an illusion of complementary colors occurring in the light and shade, the painter can't depend on this illusion and should delicately feel his way to achieve a proper harmony.

Certain atmospheric considerations must be taken into account under any light conditions. The rules of atmospheric perspective dictate that objects receding in space become cooler and lighter in value. White and blue, however, tend to darken and warm, as can easily be observed in the warmth of a distant sky. Additionally, objects at close range possess a sharp distinction of light and shade. However, when seen through layers of atmosphere, these distinctions diminish until finally becoming imperceptible.

These are but a few of the basic principles of light that I have found to be most edifying in the development of my painting. It can be an exacting and scientific subject for study, which is really somewhat of a paradox when you consider light's capacity to convey much of a painting's emotional and spiritual essence.

SEVEN-POINT SKULL

The idea of painting a skull and antlers is one that I've been ambivalent about for quite some time. With several hunters among my friends, trophy racks seem to be omnipresent. Their clean and expressive curves lend themselves enticingly to design, yet I have deliberately avoided using them primarily because it has been done so often and so well by the likes of Georgia O'Keeffe and Andrew Wyeth. However, upon noticing this skull hanging on a wall in direct frontal light, the beauty of its symmetry compelled me to paint it.

With the infinite variety of positions and lighting available, I had never really thought of the most obvious until that moment. In spite of the immediate appearance of symmetry, the antlers are not at all balanced. It is precisely this subtle asymmetry that gave the idea its appeal.

In my studio I positioned the skull directly under the skylight to most nearly approximate my original observation. The top lighting actually enhanced the austere image I sought and cast a vibrant warm shadow against the cool background wall. Thus, the combination of sweeping arcs and formal balance set this composition apart as a rather unprecedented departure from the norm for my work.

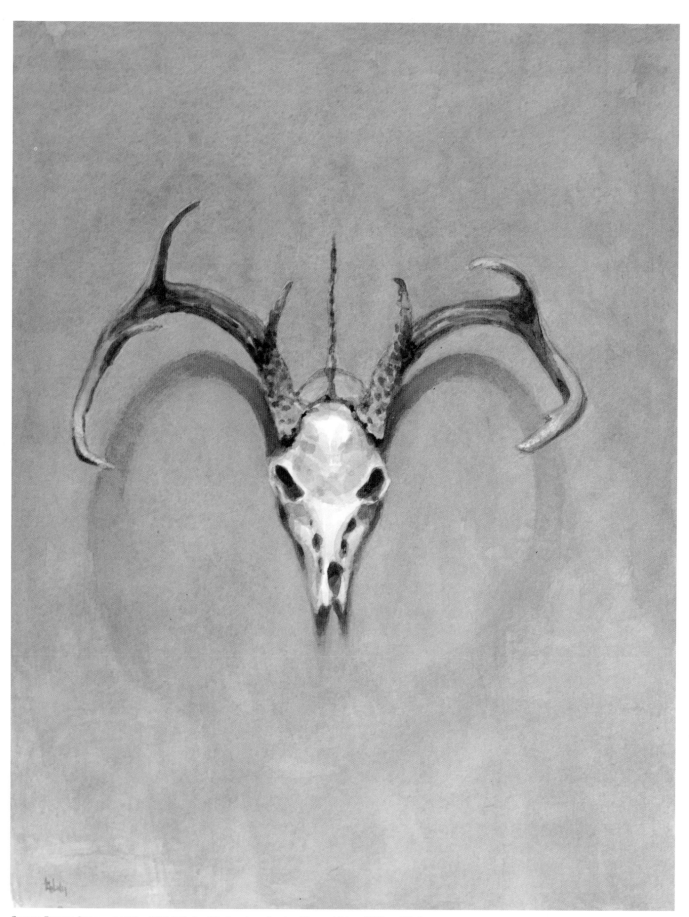

SEVEN-POINT SKULL, *11⅛″ × 8½″ (28.3 × 21.6 cm), collection Dr. and Mrs. William Rigsby.*

Woodchuck Holes, *7½″ × 11¼″ (19.1 × 28.6 cm)*, *collection Jeremyn Davern.*

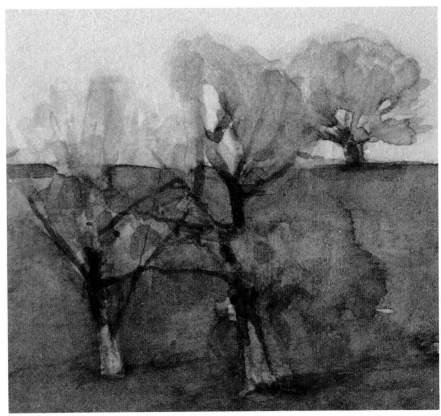

WOODCHUCK HOLES

This painting has an extremely simple abstract composition consisting basically of one large positive mass in a horizontal format, which divides the image into three spaces—sky, land, and water. Although the details within the positive space have their own subtle interest, they are only of secondary importance and are subordinated to the composition as a whole in order to strengthen the visual impact of the entire mass.

This work was derived totally from memory and evolved from a preliminary pencil drawing done directly on the watercolor paper. Before any paint was applied, the drawing was thoughtfully planned, undergoing several changes to eliminate trees and other objects to attain visual simplicity and compositional strength.

Depicting the light of a gray day accurately from memory is the result of cumulative experience based on observation and practice, as opposed to adhering to a pat formula or technique. Through constant scrutiny of light and atmosphere under ever-changing conditions, I find the light on a gray day to be warm. There are exceptions, of course, but this seems to be the general rule. The shadows are also warm, but more toward the cool side, and they are softer and more diffused.

The bare trees observed in the detail above are a good example of how easily a complex subject can be reduced to a simple mass. The right shape and value can suggest the superfluous detail, and the image reads as the eye would actually perceive bare branches in the distance. By merely suggesting the branches as one mass and one value, the trees have visual credibility without the clutter of extraneous detail.

The soft quality of light on a cloudy day is also revealed here by the hazy shadows and lack of strong value contrasts and hard edges.

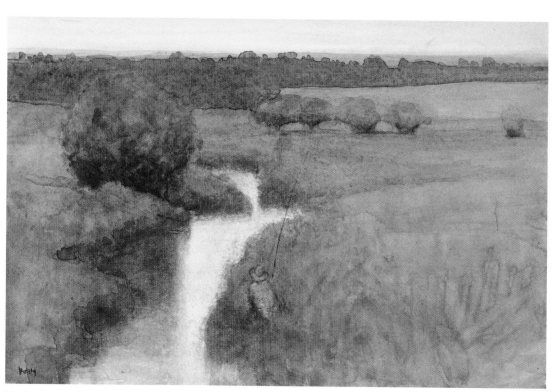

UPPER WISCOY, 8¼" × 12½" (21.0 × 31.8 cm), collection Joseph J. Prorok.

UPPER WISCOY

My eye has often been captivated by an iridescent serpentine of sky mirrored upon a brook as it winds through a grassy meadow. This spectacle becomes most evident toward evening; however, in this particular instance, I have depicted it earlier on an overcast day. The essence of the design is again embodied in a simple division of the picture plane into two basic values. The shape of the sky's reflection upon the water formed the seed of my original idea. With the diffused overhead light of a gray day, the trees and bushes are all uniformly top lit and appear darker in value than the horizontal meadow. The green of the grass cools markedly as it recedes into the distant atmosphere.

The figure of a fisherman nested in the deep grass reiterates a motif that is common in my landscapes. Most of them include an individual that characterizes a harmonious relationship with nature, a person quietly drawing sustenance from his environment. He often transports the viewer directly into the scene by providing a source of self-identification, thereby further enhancing one's personal involvement with the landscape.

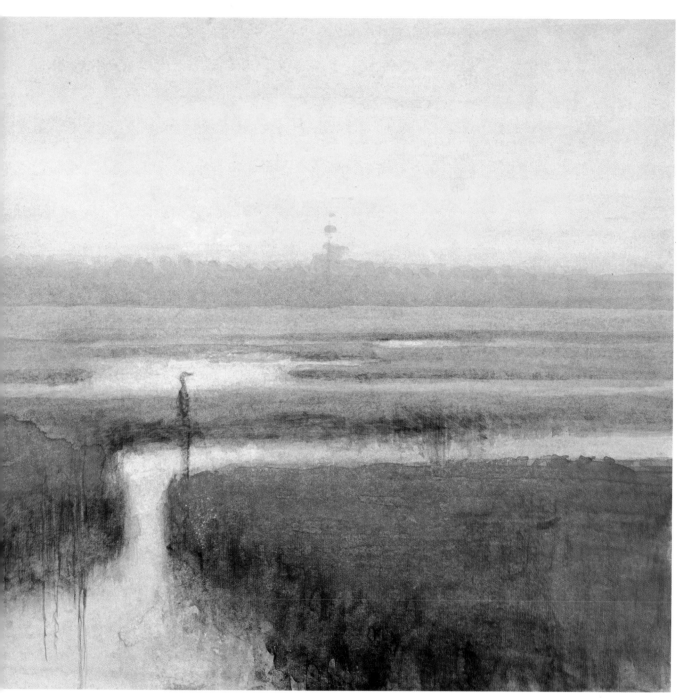

A Heron on the Marsh, 9″ × 12¼″ (22.9 × 31.1 cm), *collection George Carlson.*

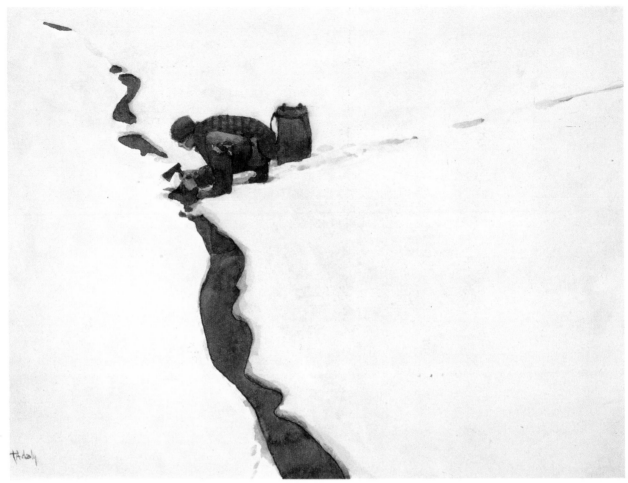

MAKING A SET, 7¾" × 10½" (19.7 × 26.7 cm), collection Gebhard Keny, Jr.

MAKING A SET

My oldest son shares my interest in trapping; and an image of him kneeling to make a muskrat set, silhouetted against the fresh snow, inspired me to later paint this picture. I do few snow pictures, as the stark severity of dark values against light ones can be intimidating. The correct placement of each element is critical since the patterns are strong and hard-edged, giving the design a bold, immediate impact.

Here I used the stooping form, packbasket, and footprints to create a horizontal element that would offset the vertical serpentine shape of the rivulet. As the water runs in and out of the snow, it forms isolated positive shapes against the vast negative field. These shapes and their placement are vital in a picture of this clarity and open design.

The fresh snowfall appears warm on a bright, overcast day. Cast shadows are virtually nonexistent, because so much bouncing light diminishes their value. Instead of reflecting the sky, the water in this picture is the color of its mud bottom. This is because it is reflecting unseen woods beyond the picture. The dark value of the reflection allows the water to be transparent, as opposed to acting as a mirror of the sky. Had the woods not been present, the stream would appear as light in value as the snow.

While the execution of the water appears to be quite simple, it was handled very delicately. A series of washes were built up gradually until I felt that the right value was achieved.

COON TREE

The misshapened tree in this painting is the sort that often houses a raccoon den—hence the picture's title. The nocturnal coons favor the hollowed-out cavities of trees such as this that have sustained damage from lightning or insects because they provide a relatively inaccessible haven for the young kits.

As in other moonlight pictures, I used a combination of cadmium orange and ultramarine blue as the basic palette. Working with the original neutral blend of these complements, I played warm variations against cool, maintaining the latter primarily for the sky. A mixture of cadmium orange and ultramarine blue is a tried and true color formula for moonlight and one that could be used exclusively with successful results. While I depend upon this combination as a foundation, I often enhance it with alizarin crimson or pick up touches of local color that might penetrate the darkness.

Another guiding principle involving trees in light is exemplified almost to the point of exaggeration: as the size of a limb decreases with distance from the trunk, its apparent value seems to lighten as well. This is true because the thinning branches block progressively less light. The result is a halo effect, where the light wraps around the branches, creating the illusion of a lightening value. This effect becomes even more exaggerated when the branches cross a strong light source, which, in this case, is the moon.

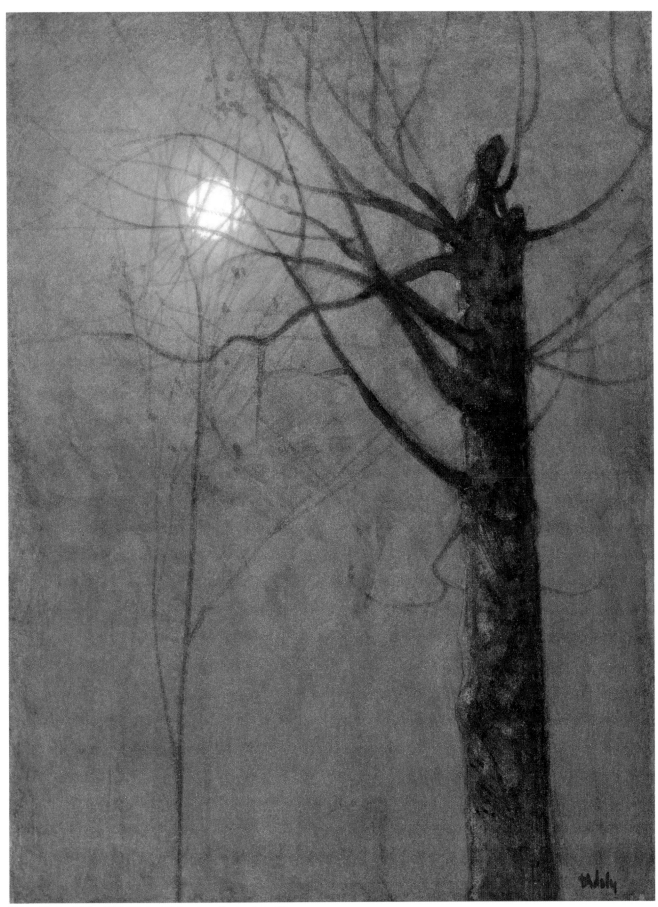

COON TREE, 9½″ × 7⅛″ (24.1 × 18.1 cm), *collection Lois Wagner.*

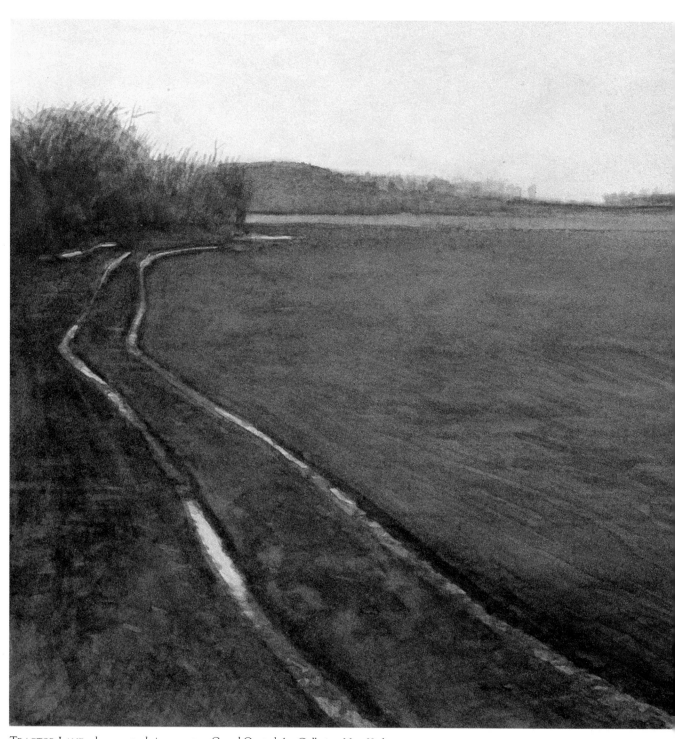

TRACTOR LANE, *shown actual size, courtesy Grand Central Art Galleries, New York.*

"Toward evening, as the sun sets and the shadows elongate, the evidence of the light's direction becomes sharply exaggerated. The upright planes, such as trees and walls, are cut in half with sunlight and are no longer the darkest values."

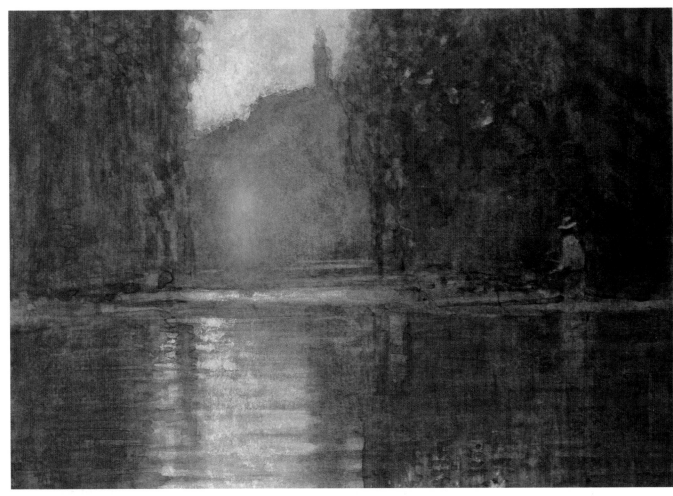

EPHEMERELLA DOROTHEA, *7″ × 10″ (17.8 × 25.4 cm), collection Daniel M. Galbreath.*

EPHEMERELLA DOROTHEA

The ephemerella dorothea is a small sulphur-colored mayfly that appears in late spring and early summer. This picture depicts an event that fishermen refer to as a "spinner flight." As a prelude to mating, the flies gather in large numbers, forming clouds over the riffles in a stream. After mating is completed, the flies fall spent on the water, having already deposited their eggs in the aerated riffle, where the nymphs will be assured a sufficient oxygen supply. During June and July these congregations of mayflies appear every night, sometimes so vast and dense that they can shroud an entire riffle with an opaque cloud.

In this painting, light is striking the hazy mass of insects and illuminating it, transforming it into an almost supernatural aura hovering amid the dark walls of trees. There is a mystical quality to the picture, as the lone fisherman appears to be drawn toward an apparition.

This painting began as big broad washes, first establishing the fundamental shapes and values. In order to make the masses richer and more textured, I gradually developed the paint quality within each area, being careful to restrict the range of values in each group so as not to break up the basic masses.

OFF COON HUNTING, *8½″ × 12″ (21.6 × 30.5 cm), collection Mr. and Mrs. C. Stadler.*

OFF COON HUNTING

This is one of my earlier moonlight paintings, inspired by a view from my yard. A group of raccoon hunters parked their truck in front of my house and set out across an adjacent field in the dark. The chilling sound of their hounds in the woods and the eerie moonlit cornfield created a feeling that I chose to express visually.

DECEMBER AT PORT WELLER, *shown actual size, private collection courtesy Keny and Johnson Gallery, Columbus, Ohio.*

STUBBLE, *7⅝″ × 12¼″ (19.4 × 31.1 cm)*, *courtesy Grand Central Art Galleries, New York.*

DECEMBER AT PORT WELLER

This painting is unique in that it was commissioned specifically upon request for the cover of a sporting periodical. I seldom work on commission as the restriction of subject matter and painting time diminishes the spontaneity that is the essence of my work. In this particular instance, the only limitation on subject matter was seasonal, but the deadline was extremely tight. I was fortunate to quickly seize upon an idea that enthused me, so that I was able to inject it with the kind of vitality that renders a painting successful.

My principal concept was to create an isolated shape suspended within an ethereal fusion of atmosphere and water. The hunter, boat, and oars provided the kind of shape that I wanted, while the decoys added balance and a suggestion of receding space.

I strove to capture a prevailing feeling of stillness that occurs after the wind has died down and a light snowfall obscures the senses. Consequently, the picture space is extremely shallow, without any definition of a horizon. There is only a slight movement of the water's surface and the only suggestion of filtering sunlight is a subtle, luminous glow.

This is the only painting I have ever done of falling snow, and I had only my memory for reference. I applied the principle of white warming at a distance and made the foreground snowflakes larger and cooler than those farther away. At the top of the picture, where the snowflakes are seen against the sky (which is almost always the lightest value in any landscape), they appear to be dark.

JULY DOROTHEAS, *12″ × 8¼″ (30.5 × 21.0 cm), courtesy Grand Central Art Galleries, New York.*

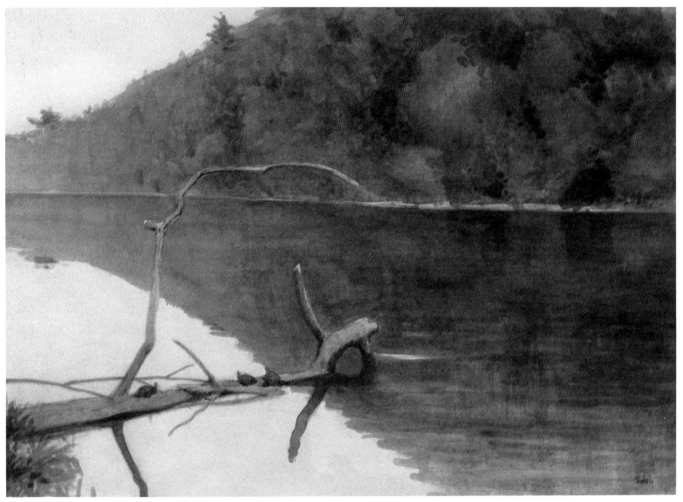

PAINTED TURTLES, 8″ × 11⅝″ (20.3 × 29.5 cm), *courtesy Stremmel Galleries Ltd., Reno, Nevada.*

"The rules of atmospheric perspective dictate that objects receding in space become cooler and lighter in value. White and blue, however, tend to darken and warm, as can easily be observed in the warmth of a distant sky."

COLOR:
interplaying warm and cool

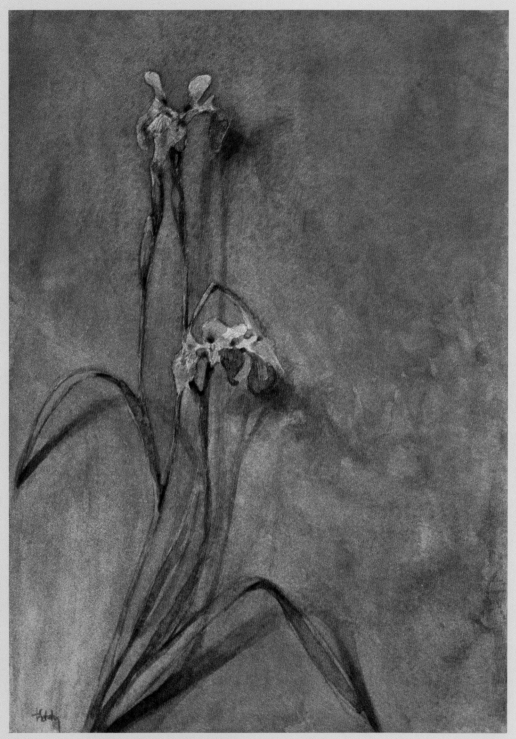

BLUEFLAGS AND SHADOWS, *10⅜″ × 7⅜″ (26.4 × 18.7 cm), courtesy Grand Central Art Galleries, New York.*

In my opinion, mastery of color is the most elusive skill to challenge a painter. A proficiency in design and drawing is far more readily attainable than the ability to unravel the enigma of pigment. In painting, color is virtually everything. It is synonymous with form and light and functions as the primary conveyance for personal expression. Yet it is obviously more complex than a subjective expression from the heart, because color can also be analyzed with scientific precision.

As a guide to understanding color, I strongly recommend Albert H. Munsell's *A Grammar of Color*. In this outstanding book, which has earned wide acceptance as the standard, the author has devised a three-dimensional color chart that includes the color properties of chroma, hue, and value. Although the creation of precise balances of color in purely systematic and analytical formulations may seem inconsistent with artistic expression, once this knowledge has been assimilated you can begin to recognize color harmony and understand why certain color relations are inherently pleasing to the eye.

Color, like anything else, becomes personal through familiarity, and that requires repetition. After ingesting the scientific rudiments, the slow and tedious process of experimentation begins. I am still quite tentative with color and I am most comfortable restricting myself to a rather limited palette. Of course, a simplicity and understatement in color is congruent with the basic restrained and classic tenor of my work. By carefully balancing my color in a quiet, subtle manner, it contributes to the general sense of comfort and serenity. A strident assault of harsh color may grab the eye initially, but it often quickly wanes in appeal. A very basic concept is to limit strong color to very small areas, while large areas should be more neutral in chroma. Because my spatial divisions tend to be large and broad, my color selections are in turn more muted and middle range.

In order to sustain visual interest, a picture's color can offer variation in value (light/dark), chroma (weak/strong), and hue (warm/cool). The oscillation between warm and cool seems to evoke the most perplexity. There are several basic axioms regarding these relationships that are best learned at the onset, even if only as a rough guideline. Whatever the temperature of the light, the shadow will usually be the converse. For instance, cool indoor light creates warmer shadows, while warm outdoor light makes them relatively cool. People often fail to treat the color of the lit and shaded areas of an object as two entirely separate shapes of distinct color. They will merely darken the object's local color and declare it a shadow. In actuality, the two areas should be handled as separate entities, with the shadow often being saturated with the complement of the light.

A keen sensitivity to the relative warmth or coolness of color is a fundamental necessity to the representational painter, and its importance cannot be overstated. Like other aspects of painting, the academic principles are necessary as a framework for eventual intuitive judgments.

OCTOBER FISH

The grotesque configuration acquired by the spawning male brown trout has always fascinated me because it graphically illustrates the truly savage nature of the fish. Like the Pacific salmon, the brown trout undergoes disfigurement correlative to its breeding status, developing a pronounced underslung and hooked jaw. This particular fish was caught in a tributary to Lake Ontario where it had come to breed in the fall. Making the transition from its pale silver lake coloration to the dark ochres and browns of the stream, it served as an interesting color study.

In *October Fish* I exercised a bit of artistic license and inverted the rules of painting light to satisfy my own sense of visual harmony. The brown trout exuded too much warmth for me to comfortably acquiesce to theory, so I allowed my intuitive judgment to deviate and let cool color dominate where the light enters.

I have effectively contrived several pictures based upon the torpedolike form of a single fish. Here, the cast shadow on the background wall further accentuates the trout's hydrodynamic shape. The cool blue of the wall complements the fish's ochre sides in addition to repeating the hue of the rings that encircle his spots. Thus, the combined impact of both the aesthetics of the trout's aberrant shape and coloration and the concept of them as a transitory and bizarre caricature of the fish's feral nature made an irresistible image for me to translate into paint.

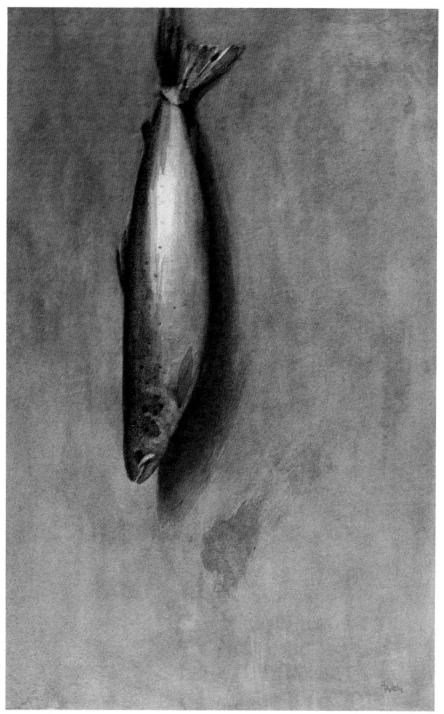

ST. JEAN FISH, *12¾″ × 8⅛″ (32.4 × 20.6 cm), courtesy Grand Central Art Galleries, New York.*

ST. JEAN FISH

This painting offers an interesting contrast to *October Fish* (see facing page). As a pair, these two paintings clearly illustrate divergent application of warm and cool color, while many other variables remain constant. The cool blue and silver salmon in *St. Jean Fish* required a warm wall to play against, but the converse was true in *October Fish*. Generally, as is true here, the background wall should be warmer and darker near the light source (in this case an overhead skylight) and will brighten and cool as the entering light radiates across it. Thus, *St. Jean Fish*, is considerably more correct and "real" in its portrayal of the properties of indoor light than is *October Fish*.

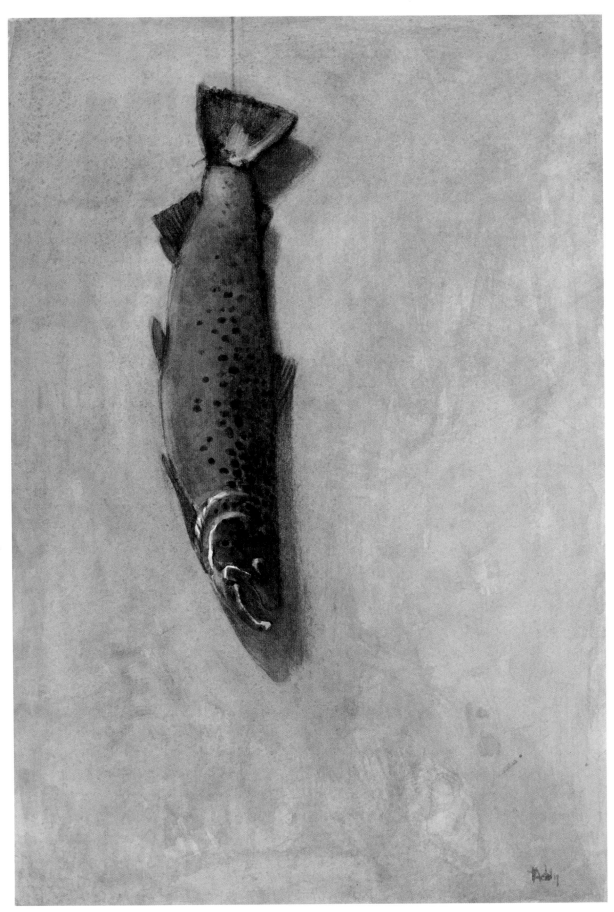

OCTOBER FISH, *13½″ × 9⅛″ (34.3 × 23.2 cm), collection Martin Murphy.*

WORKING SMALL

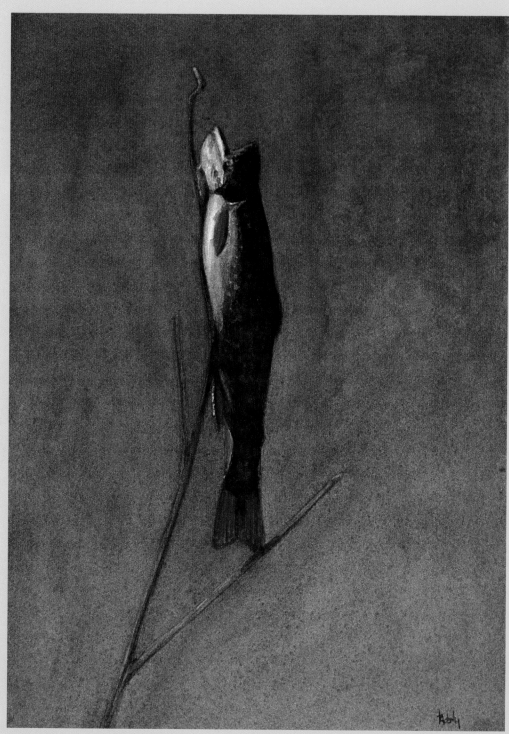

NATIVE TROUT, 9½″ × 7″ (24.1 × 17.8 cm), courtesy Grand Central Art Galleries, New York.

M ost of my early watercolors are quite small. It took a number of years for me to enlarge my format comfortably, although my present paintings are still considered smaller than the norm. The small size evolved from my frequent practice of painting quick thumbnail sketches out-of-doors for use as later reference. I would rapidly execute two or three sketches in order to capture the shapes, colors, and light of a moment rather than attempt to complete an entire painting on the scene. The small sketches also proved to be more convenient, as they were portable and dried quickly, in addition to providing a fresh, spontaneous image. I would strongly advise anyone learning about watercolor to practice doing small pictures with a large brush; it forces you into simplicity, into seeing and painting only the large masses and relationships rather than dwelling upon detail.

CAMPFIRE ON PLATTE RIVER, *shown actual size, collection Daniel M. Galbreath.*

LAKE ERIE MINNOWS, shown actual size, collection James Roy.

LAKE ERIE MINNOWS

The small dimensions of my early landscapes translated into my still lifes as well, as is the case with *Lake Erie Minnows*. I've always found the painting of silvery fish such as salmon, smelt, and sheepshead to be particularly challenging. These tiny emerald shiners used for perch bait were a less conventional choice. Because the fish were too small to hang, I decided to lay them in the groove of a plate, using the arc to create a divergent spatial division.